Photography in the age of the computer

PhotoVideo

edited by Paul Wombell

Rivers Oram Press, London

This book is published in association with Impressions Gallery of Photography, York
and with the travelling exhibition 'Photovideo'

First published in 1991 by
Rivers Oram Press
144 Hemingford Road, London N1 1DE

Published in the USA by
Paul and Company
Post Office Box 442, Concord, MA 01742

Set in Bembo, OCRB and Isonorm
by nice using Macintosh IIsi, Quark version 3.0

Printed in Great Britain
by Butler & Tanner Ltd
The Selwood Printing Works, Frome, Somerset BA11 1NF

a nice © design with Kate Tregoning

British Library Cataloguing-in-Publication Data
A catalogue record for this book is available from the British Library

ISBN 1-85489-036 0

Photo

– relating to light, or produced by light
short for photograph/photography; indicating the
process where an image is fixed onto
light-sensitive paper by the use of a camera, and the
chemical processing of this material to produce a
print, slide or film
*see also photocopy, photofit, photojournalism,
photogravure, photogenic, photomontage*

Video

– relating to the transmission or reception of a
televised image; method of recording and
playing-back images (and sound) that are stored
electronically on magnetic tape and where, unlike
film, the image can be played-back
instantly or, once encoded, subjected to a
variety of video effects
short for video cassette recorder, video camera
*see also video monitor, video wall, video game,
video nasty, video link, video still*

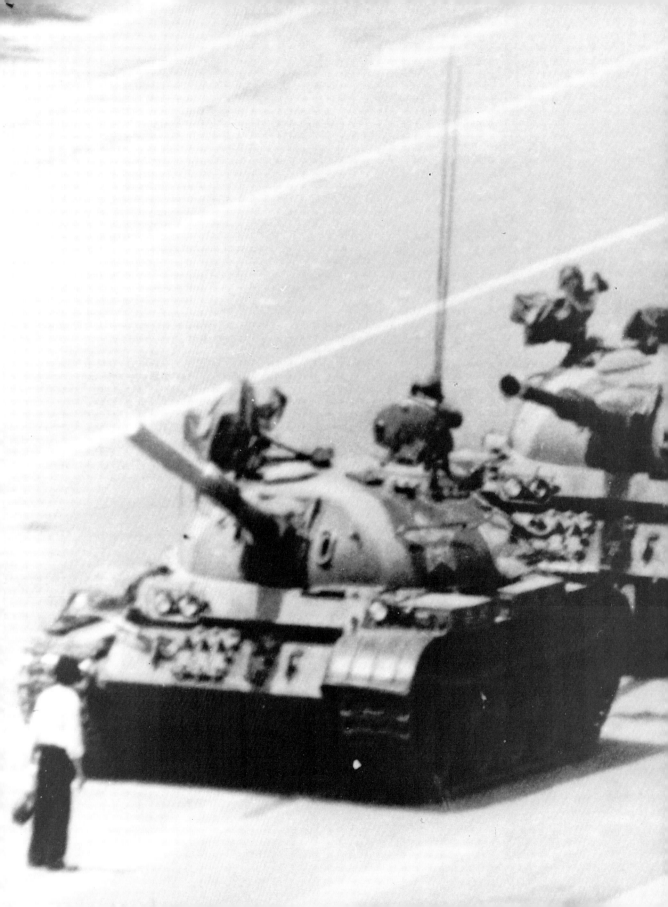

contents

Introduction **0**:0
Steven Bode and Paul Wombell

The end of photography as we have known it **1**:8
Fred Ritchin

To control our image: photojournalists meeting new technology **2**:16
Karin Becker

Computer averaging and manipulation of faces **3**:32
Philip Benson and David Perrett

Into the image: visual technologies and vision cultures **4**:52
Kevin Robins

Mechanical reproduction to endless replication **5**:78
Jeremy Welsh

Screen War **6**:92
Paul Wombell

Multimedia as cultural product **7**:104
Graham Howard

Fortress Europe: tagging the other **8**:112
Keith Piper

Taking new ideas back to the old world: talking to Esther Parada, Hector Méndez Caratini and Pedro Meyer **9**:122
Trisha Ziff

Tiananmen Square, Beijing, June 1989
Image taken on 35mm film using a conventional camera. The film was processed and the negative scanned by a machine which used a beam of light to convert it into an electronic signal. The image was thus transmitted in electronic form, by telephone lines, from China to the offices of Associated Press.

Steven Bode

Paul Wombell

in a new light

Paul Wombell has been the Director of Impressions in York since 1986. While at Impressions he has curated over thirty exhibitions, which include 'The Mind' (1987); 'The Globe' (1989); and 'Heritage, Image and History' (1990). He has curated the exhibition 'Photovideo' to coincide with this publication. At present he is researching an exhibition on the representation of the atom. Prior to his work at Impressions he was regularly exhibiting his own photographic work and writing about photography.

Steven Bode is a director of the Film and Video Umbrella, London, with specific responsibilities for video and new media projects. He has written extensively on video, photography and computers for *City Limits, Direction, Videographic,* and *The Face.*

Until recently, at least, it was possible to define photography as a process involving optics, light-sensitive material and the chemical processing of this material to produce prints or slides. Today, though, that definition is subject to change. Technological innovations such as the video-still camera are shifting photography from its original chemical basis towards electronics, opening it to all the possibilities of data transmission and processing. It is not overstating it to say that the advent of this new technology is changing the very nature of photography as we have known it.

The video-still camera, as its name implies, moves photography into an increasingly closer relation to video. Like a video camera, it uses a mosaic of light sensors (pixels) to convert light entering the lens into an

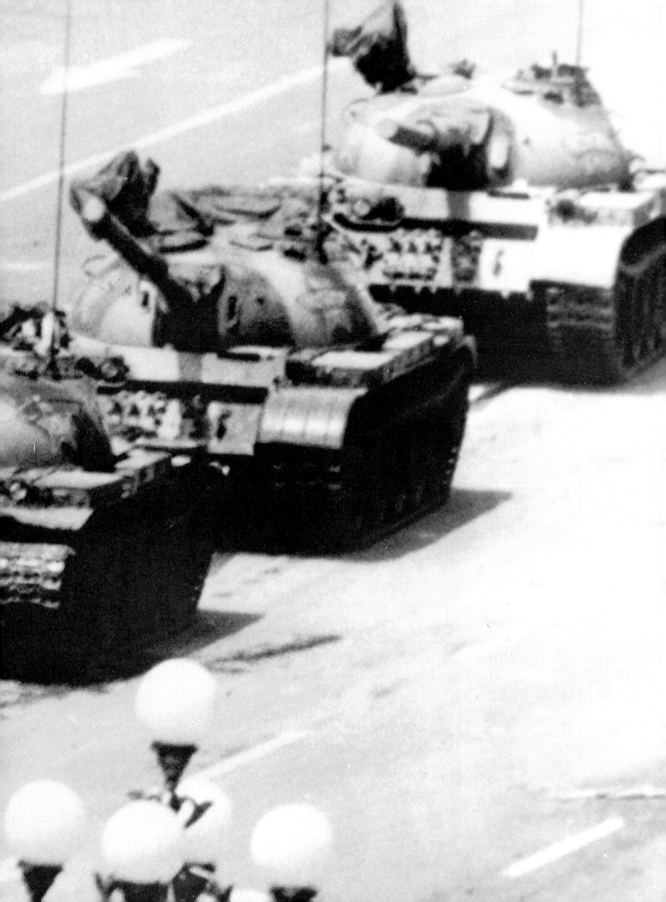

electric signal which can be recorded on a magnetic floppy disk or memory-card. It is then possible to output that signal as an image to be shown on a television screen or, using a suitable photocopier, produce 'hard copy'. Once it is stored electronically, it is also possible to either edit or enhance that image in a number of different ways. Consequently, one can foresee the processing and printing of photographic images increasingly moving out of the darkroom and taking place by the light of the computer screen.

Once photographic images become encoded as units of electronic information, they can enter into a global communications network that, via today's computers and telephone lines, can send information around the world in a matter of seconds. In the same way that money is traded and exchanged as an electronic pulse between dealing rooms on different continents, photographic images are being transferred – between military bases, corporate offices, news agencies, image-banks and galleries. This flow of images is not constrained by national boundaries, physical movement, or production time considerations. Photographs are part of our instant communication system, where speed of representation is everything.

The consequences of this are potentially huge. To take one example among many, the suppression of the pro-democracy demonstrations in Tiananmen Square during 1989 was witnessed by the Western media. When the Chinese government tried to stop their reports leaving the country, Associated Press photographers found a way of side-stepping the problem by sending back pictures over telephone lines. Although they were working with conventional still cameras, where film had to be chemically processed, their negatives could be electronically scanned and relayed back to their offices in the United States. Would the newspaper coverage of Tiananmen have had the same emotional force if these

images had not been seen so soon after the event?

It is not only this facility of moving images from place to place that has been such a boon for news reporting. In a world where newsprint competes with television for coverage of stories, the speed with which pictures can be placed on the front page presents huge advantages. It is not surprising then, that some newspapers have already made the move into video-still technology or, indeed, that increasing numbers of news photographs are taking on what one might call a 'video look'. Recent events in Eastern Europe and during the Gulf War were either not accessible or out of bounds to photographers, and for newspapers to provide visual coverage it was often necessary to use images taken from television broadcasts. As a consequence, this 'video effect' (in which images are broken down into horizontal lines, sometimes with a black border) has become an index of 'immediacy', replacing the 35mm blurred black-and-white picture as signifying the dynamic news event.

Yet as increasing numbers of picture editors make use of this practice of 'frame-grabbing' there is concern that some of the specific aspects of photo-journalism may be lost in an era of generalized image reporting. Indeed, as photographic images become transformed into bits of electronic information, the more likely it is that photography will become subsumed within a broader overarching electronic communications medium. And not only photography, but other visual media as well. In 1989, the Japanese trading company Mitsui opened a gallery in London. Using video-still technology, they have simultaneously sold paintings in London and Japan. An interested purchaser in Tokyo can, either by telephone or by satellite transmission, view paintings on a high-definition television screen from the London gallery. Yoshi Fukushige for Mitsui predicts that this form of technology could make museums and galleries redundant: 'Fine art is just another aspect of our trading, and my interest

is purely in how technology can affect business.'

Photographs from existing picture libraries are already being encoded and assembled in an electronic data space where more than a million images will be on file. This has huge implications for the ways in which photographic images are *seen* – offering the individual far greater access to this storehouse of visual images; yet requiring that they are viewed more and more via the medium of the screen.

The speed with which images can be called up or combined also brings a new range of creative possibilities. The composite image on the front cover of this book, produced by Philip Benson and David Perrett at the Department of Psychology of St Andrews University, is one example of the startling things that can be achieved. Here, with the aid of a computer graphics programme that displays and stores each image in a regular configuration of pixels, the portraits of the last ten British Prime Ministers have been merged into one 'archetypal' identikit figure.

The potential for new forms of creative involvement does not stop there. With the arrival of the kind of interactive multi-media system that Graham Howard outlines in his essay, not only still and moving images but digital audio, graphics and animation, and all manner of electronic data, can be combined. In the home, images shot on the new electronic cameras will be displayed on a television screen that will be at the heart of a fully integrated home entertainment/information system. In the gallery, images will be presented on monitors. A computer keyboard will be able to call up a range of supplementary information; making it possible for the viewers, if they so desire, to build up a more complex picture of a chosen image: drawing upon sound, graphics, video or a range of other images relating to that particular scene.

In one sense, this involvement with other media is nothing new. Throughout its history, photography has always enjoyed a complex

relationship with other text-based or visual information media. Much of our understanding of photography comes from seeing images in newspapers, magazines and books. As new forms of electronic publishing develop which involve video and computers, the still photographic image will find a new context in which to function. Even so, such changes will inevitably come at a price: many of specificities like picture size and print quality will end up being lost to fit the requirements of the screen.

They are not the only things that may be lost. With the arrival of new and increasingly seamless ways of editing and changing images, our traditional belief that the 'camera never lies' is brought into question. Once on screen, and with the appropriate software, images can be totally transformed, leaving no sign that they have been tampered with. Already there have been several instances of photographs being altered to fit the requirements of the page, and others still where parts of a scene have been either enhanced or removed to give the picture 'greater impact'. As Karin Becker's essay shows, it is a practice that is creating great concern within the photographic community. Furthermore, as Fred Ritchin asks, who stands to lose when the 'truth' of the photographic image stops being accepted? And will the more complex, multi-faceted 'truth' that is offered by multi-media be enough to compensate?

Perhaps the most profound effect of the new technologies is their capacity to challenge categories and assumptions that have been at the heart of traditional ways of seeing and thinking. Jeremy Welsh suggests we need to come to terms with the full significance of these changes if we are not to be submerged under a rising tide of ever-more spectacular media images. Kevin Robins and Keith Piper also warn that behind the Utopian discourse of freedom and enlightenment that has become associated with the new media technologies lurks another, hidden, agenda. As Piper cogently argues, the kind of hugely expanded infor-

mation network brought about by new computer technology may, in theory, allow us access to all sorts of new creative possibilities; but it also permits a more intensive and potentially sinister monitoring of ourselves as individuals. As we enter into a future in which our vision of the world around us is increasingly mediated by images seen via an electronic screen we might well ask the question of just who is really watching who?

That said, these new forms of electronic image-making are providing artists and photographers with new ways of representing this changing visual and cultural landscape. A number of photographers have already responded positively to the speed and flexibility that the new technology can offer them. And, as their interviews with Trisha Ziff reveal, Esther Parada, Hector Méndez Caratini and Pedro Meyer are producing work that not only pushes at the creative and aesthetic boundaries but also has a strong cultural and political dimension. In the same way, we hope this book and the accompanying 'Photovideo' exhibition provide an insight into how new technology is transforming the field of photography, not only by highlighting its creative potential but also by raising some of the wider cultural questions that need to be addressed.

We wish to acknowledge the important contribution that other people have made to this book and accompanying exhibition. The idea for this project came out of a conversation between Paul Wombell and Jeremy Welsh lamenting the lack of interest in Britain in developments in media technology, and in particular in the emerging relationship between video and photography. Jeremy was then working at the Film and Video Umbrella, London, but has since moved to Norway to take up the position of Head of the Intermedia Department at the Kunst-akadamiet in Trondheim. He has, however, continued to contribute to the project by telephone and fax.

The project could not have happened without the support of the Film and Video, Visual Arts and Photography Departments at the Arts Council of Great Britain. Valerie Brown, Mona Hatoum and Caroline Vincine have also made important contributions to the project. Also Canon (UK) Ltd and Sony (UK) Ltd made equipment available to the artists and photographers who have produced pieces for the accompanying exhibition. We thank them all for their support and assistance.

Fred Ritchin

the er
photo

Fred Ritchin is author of *In Our Own Image: The Coming Revolution in Photography* (Aperture, 1990). He writes and speaks widely on issues relating to documentary and electronic photography, and teaches at New York University. He has curated photographic exhibitions including 'Contemporary Latin American Photographers' and 'An Uncertain Grace: the photographs of Sebastiao Salgado'. Ritchin is the former picture editor of the *New York Times Magazine* and executive editor of *Camera Arts* magazine.

The photograph becomes newly malleable, able to fit into any space required, able to display the requisite elements next to each other when required. One need not filter an image in advance – the computer allows one to correct for colour at any time.

d of graphy

as we have known it

Photography used to serve as a reality test. One saw something, or thought one saw something, or even thought something, and the photograph was there as confirmation or denial; or at the very least to be argued with, for the photograph could not be dismissed. And if one had never been where the photograph was taken, the image existed as a potentially powerful counterbalance to the assertions of all those who were telling you what had been going on. Somehow we even made the mistake of thinking that the photograph was unbiased.

The photograph was often considered more reliable than the human verbal account, even when the human doing the telling was very powerful. A popular, charismatic US presidential candidate Gary Hart, was reported to have been engaging in extra-marital socializing yet strenuously denied it. However, neither the media accounts nor his denials were as effective as the photograph which was produced which showed him with a young woman on his lap (on a boat unfortunately called the 'Monkey Business'). Hart quit the campaign.

Even more telling was the acceptance of the photographic evidence of the massacre at Tiananmen Square despite assertions to the contrary by the government of the largest country in the world. The little rectangles of photographic paper have often managed to

convince (remember Kurt Waldheim in Nazi uniform) when other forms of documentation have been less compelling.

But photographs now seem less likely to win and the losers in this competition for control of our sense of reality are likely to be those with less power. The growing disbelief in photographs will hurt those like the pro-democracy advocates of Tiananmen Square whose existence was being refuted by a powerful government, and help those like Gary Hart who are already in power and have much to lose.

In recent years photographs have been increasingly excluded from major events such as wars and reserved for minor events like a politician walking a dog. War photography, for example, is a case of the highly visible (we *saw* many of the dramatic events and implicated peoples of the Second World War and the Vietnamese War) becoming invisible. The more valuable, transcendent tradition we had previously attributed to photography was making the invisible newly visible.

In the case of the latest war in the Persian Gulf the visible was made so invisible that already there is a nostalgia for the imagery from previous wars. Military historians, to say nothing of the voting public, are left without much to contemplate except for some imagery made from the point of view of 'smart bombs' (human beings having been considered too subjective, able to see the tragedy in massive amounts of death and maiming). When images did finally appear of the numerous casualties in a Baghdad bomb shelter, the *Los Angeles Times* summed up the new 'spin control' on its front page, 'Images of Death Could Produce Tilt to Baghdad'.

Even the *New York Times* ran an editorial protesting the banning of photographers from the airfield where the US war dead were being shipped back in all their existential end-of-the-line, this-was-war-as-well palpable, static solidity. The policy was enacted, we were told, to protect the privacy of the families. (It is a logic that could be expanded to include all those fighting, all those hurt – perhaps any of us suffering from tragedy in our civilian lives anywhere.)

However, we must not lose our perspective. It is not only in the Persian Gulf but it has been at least a decade in which we have missed much of war's trauma. We have been much more likely to miss it in situations where governments involved have had the power and savvy to keep image-makers out, Grenada, Malvinas/Falklands, Panama, South Africa, Syria, the West Bank, Argentina – violence both between countries and within has been, to use the modern term, 'disappeared'. In this most covered of worlds by media bristling with new technology, we now await its uncovering.

We have seen in magazines the disappearance of the picture essay, replaced by exciting single images which tend to illustrate the way an up-scale world should be, rather than attempt any of the in-depth exploration of the world for which the essay was prized. The glory era of the multi-page essay, particularly in the United States, is long gone. Now photographers work for the production of small books, in galleries, occasionally in large museums. They are today's poet-artists, acknowledged for their articulate subjectivity and, for the same reason, less convincing with their photographic evidence to the general public.

In particular I think of an experience I had with the images of Sebastiao Salgado, a Brazilian photographer who worked over a fifteen-month period in 1984-5 with *Medecins Sans Frontieres* (Doctors Without Borders) depicting those suffering disease and starvation in the Sahel region of Africa. In the United States, other than two pages in the *New York Times*

and several pages in *Newsweek*, publications avoided his stark, difficult depictions taken of those caught in the apocalypse of disaster contemporaneous with the events being depicted. Of all the photographers who worked in the Sahel, Salgado was one of the few to leave Ethiopia (he also worked in Chad, Mali and the Sudan, as well as the disputed Tigre Province). However, due to the paucity of publication in the United States, his work was given little attention, even disqualified by this lack of publication for a World Hunger Year citation.

Several years later, I was invited to curate an exhibition of his work in the San Francisco Museum of Modern Art. Finally, the work from the Sahel was seen; not because of the people and situations depicted in the imagery, but because the maker of these images had been judged an artist. The agony of those people, their ongoing agony, reached the attention of museum-goers due to the composition and vision of the man watching them. We are less willing to use photographs as documents telling us something about the world as it is — it is often too hard to digest. We seem to prefer the world as it was, or as it might be, according to the sensitivities of a particular artist.

Television documentaries have also largely disappeared. We see instead docudramas, re-enactments, actors playing the newsworthy, the newsworthy acting. In the Gulf War, the scorching nightly newsreels one remembers from the Vietnam War were replaced by maps and simulated tank campaigns and 'experts' and correspondents trying on gas masks, and a flood of information which did not make up in its vastness for its lack of insight. Reporting on the Persian Gulf War too closely resembled in its unreality a group of sportscasters trying to pick the final score in advance.

Imagery, when it appeared, was subtitled by the various governments and militaries whose censors had cleared it — the message was that it was not to be believed. Or one could believe an image's message if one already believed the institution approving it. In the case of the media in the United States this might have been a saving grace, for the 'Cleared by the US military' label borrowed from the prestige of an institution far more in the public's favour than the generally excluded and somewhat disbelieving (therefore less patriotic) media.

Never before has 'spin control' and 'photo opportunity' been so easily embraced in the world, nor so successfully. The tradition of war photographers, so generously celebrated up until just recently in festivities ending the first 150 years of photography, was circumvented and very likely ended with another first — pictures seen from a bomb's point of view. The work of Robert Capa and W. Eugene Smith and Don McCullin begins to fade next to the technological wizardry of a 'smart' bomb taking its own images. The camera 'shooting' and weapon 'shooting' were finally intertwined. The subjectivity of the photograph — its obvious ability to bring bad news when one would rather not know — was replaced by the more trustworthy evidence from the video-guided bomb.

It was clearly a machine which had no emotional reaction to its imploding power so visible in the imagery. It was also a machine which, labelled 'smart', seemed to have a mind of its own, one with which we were not connected and therefore not responsible. Photography, despite growing disclaimers to the contrary had, once again, proven its remote 'objectivity', although not in circumstances applicable to our own daily lives. Such imagery was often too depressing anyway.

It is interesting, in retrospect, that the Saudi Arabians were said to have let the US forces enter their territory when confronted with

photographs taken from the air of massed Iraqi forces, yet once the conflict started, virtually no significant imagery was allowed to be produced. It is also interesting that the record-breaking book in the United States after the Persian Gulf War was not one that focused on the conflict, but one that detailed (with at least some degree of accuracy) the apparently vast distance between reality and illusion in the Reagan White House famous for its clever use of both 'spin control' and 'photo opportunities'.

There are those who marvel at the electronic revolution because it allows instantaneous communication among people in many countries, preventing a total information blackout. Electronics certainly contribute significantly to the free flow of information and ideas, yet their contribution is more akin to that of the samizdat press than that of the mainstream. Perhaps most unsettling in this revolution in perception and image production is the impact of electronics on photographic veracity.

Right now it is possible to change any element in a photograph, no matter how small or large, undetectably using digital manipulation techniques. One simply scans in a photograph or negative so that it appears on a computer screen, and employs one of a large variety of tools to add or subtract elements, or change colour or focus. One can change one's filter or f-stop after the fact, as well as making more major modifications such as the adding or subtracting of people or things.

This is now possible to do both in computers made for home use, as well as in elaborate systems designed for publications. Originally, beginning about a decade ago, it was the more expensive technology available to publications which first provided these possibilities. Since much of the technology had been designed to aid in page make-up and production before actually going to press, a virtually irresistible

temptation was being created for some with the input of photographs into digital form. Not only could they be sized and placed on the page digitally before being quickly transmitted over telephone wires and by satellite to press, but they could also be internally modified.

One of the strengths of press photography for me had been its ability, to some extent, to stay out of the editing fray. Whereas a writer's words could be and often were edited down to the comma, a photograph, once chosen for publication, was largely sacrosanct. It could be cropped and its meaning changed as a result, or a caption could be written redirecting its meanings, but the reader was finally still given a view of the world that might have some interesting information in it and not simply reflect the biases of those who saw to its publication.

Now the photograph is as malleable as a paragraph, able to illustrate whatever one wants it to. Recently we got to the point where in Europe a newspaper could publish on its front page a 'photograph' of a plane crash even when there was no photographer present. It seems that eyewitnesses recounted what had happened and a computer was used to montage a plausible image – and the image was run as a normal press photograph. Why send someone to cover an event anymore?

A spread was recently published which showed how the image of one woman, a Caucasian, could be digitally manipulated to become the image of a black woman and an Asian woman – a strategy for saving money in models' fees. *National Geographic*, in search of a vertical image, used a computer to rotate one of the pyramids of Giza behind another – the editor referred to it as simply a retroactive repositioning of the photographer a few feet to one side.

Rolling Stone magazine took the shoulder holster and pistol off the cover subject Don

Johnson of 'Miami Vice' fame in search of a more peaceful image; *Playboy* is said to have added its own logo to the t-shirt of cover subject Roseann Arquette, not known to be a fan of *Playboy*. US television star Oprah Winfrey, a strenuous but not always successful dieter, appeared on the cover of *TV Guide*, her face, it turned out, zippered onto the slender body of actress Ann Margret.

Newsweek magazine published a large opening photograph of actors Tom Cruise and Dustin Hoffman as buddies, explaining in the text that the success of the movie 'Rain Man', about an autistic man and his brother, was largely due to the chemistry between these two stars. They did not inform the reader that one was in Hawaii and the other in New York, and the image was composited later, managing to illustrate the point of view of the text.

One hears of such manipulations (it is virtually impossible to detect them) through word of mouth, since publications do not usually broadcast such modifications. The photograph becomes newly malleable, able to fit into any space required, able to display the requisite elements next to each other when required. One need not filter an image in advance – the computer allows one to correct for colour at any time, according to one's subjective memory, a strategy already being used by news photographers. Focus as well is forever malleable, so that the dialectic with the camera in its ability to impose its own mechanistic point of view – is being subsumed by the human desire to control. The introduction of the still video camera, which uses a reusable magnetic disk to record imagery rather than chemically processed negatives, means that there will be less reliance possible on an archival proof that an image was not tampered with.

Perception evolves into vision, which is the way it should be, except that the facts of the situation perceived are decreasingly valued. This is a strategy which works for art but not for documentation, and results in one vision being pitted against another like one person's word against another's.

Furthermore, and this also became apparent during the Persian Gulf war when one began to frequently see CNN credited for still photographs, the video camera's ability to provide useable, still photographs through what is called 'frame-grabbing' means that one no longer needs a multiplicity of points of view on a situation. A single video camera can provide footage both for a television station and for many publications. I heard the story of a local newspaper not having a photographer present at a fire, and having to frame-grab from the television station. The next time the video cameraman asked the still photographer why he bothered to show up, when his work was no longer necessary.

There is a centralization of control – the editor in the newsroom no longer simply selects from a photographer's images, knowing that the photographer was there. Instead he or she becomes in effect the photographer, working from the remoteness of the newsroom selecting images off a television set (the news becomes postmodern!). This is not so unlike the merging of major media giants such as Time-Warner, putting into the hands of a few the way we see the world depicted.

And photography has changed on the personal level as well. A personal computer now allows one to modify photographs of events that are personally important, such as vacations, weddings, graduations, births. One can easily place oneself in an image before the Eiffel Tower without having had to leave home. One can remove from wedding pictures unwanted guests, or give the groom more hair, or the dog a shampoo. One's grandchildren will have as

their heritage images of the family the way its members *wanted* to look, not the way they did look at the moment the photograph was made. All of this hands-on practice, or the utilization of the profusion of retouching studios that will no doubt soon open, will further degrade the reliability of the documentary photograph for the public.

It is difficult in writing about the future to know which kernel that drifts one's way is to be trusted as a reliable indicator of things to come. But just recently I had an experience which, though short, was quite intense in terms of feeling the pulse of the future.

I was invited to speak on the subject of ethics in a two-day national conference on digital photography to an audience of photographers and picture agents who make their living selling photographs. After ten minutes of attempted consciousness-raising, as we used to call it some years ago, referring to the old story of the goose and the golden egg – if no one believes photographs anymore, then they won't be worth much, no matter what genre of photography we are speaking about – someone in the audience suggested, to the rousing cheers of a large number of those assembled, that ethical issues were not really their concern. Their problem was more that of safeguarding the photographer's rights and making a profit for all concerned. Ethics, it appeared, might be the concern of photojournalists, but not of those selling photographs to non-journalistic markets.

But the discussion which lasted about half an hour provoked a number of interesting admissions, signs of what is to come. One member of the audience asserted that the era of Cartier-Bresson and the 'decisive moment' is finished, since anyone can create any 'decisive moment' he or she wants with a computer. A photographer noted for his aerial derring-do spoke up, appearing to confirm this point of view. He recounted how he had recently shown a dummy of his new book to friends and associates, and several suggested that the photographs were not to be believed. They felt it was impossible for people to be perched at such heights, the images must have been modified by computer. A picture editor from a mass-circulation news magazine came up afterwards and recounted how one of the photographs published from the Persian Gulf crisis which had a pastoral, serene feel to it was repudiated by quite a few readers, who felt that what it depicted was too perfect to ever have happened. They insisted that it too had been modified by a computer.

The mythology that the 'camera never lies' is evidently being replaced by a sense that if often does. Undoubtedly it is preferable that readers be suspicious of photographs for a variety of reasons, not least of which is the fact that each image is an interpretation of a situation, not its objective representation. But if photographs which seem to go too much against the common belief system are automatically rejected, then we have entered a new era in which there is little repudiation possible to the points of view of those in power in what we call our democracies, endowed with a 'free press'. Photographers will no longer have to be banned from certain conflicts or other events if their imagery is almost reflexively disbelieved.

Gary Hart might then have been elected President, and the protestors in Tiananmen Square would barely have existed in the public perception. Uruguayan writer Eduardo Galeano wrote, in a different context, about Latin America in his recently released *Book of Embraces*: 'It has become unnecessary for the police to ban books: their price alone bans them.' Similarly, while still respecting the rights of the press and public, one may not have to ban cameras.

One searches for a metaphor which encompasses the changes. For me it is quantum theory. That which is observed is changed by the observation. There are no embedded social truths to be ferreted out. There is nothing more real than anything else. Into the societal vacuum comes power, both overt and covert, determining truth. Logic, prediction, and specificity are concepts which are being devalued, replaced by a sense of overwhelming chaos.

Photography has, in a significant way, been degraded. Those not in power have lost a sometime friend, and those in power are losing the ability to judge the world and themselves from other perspectives. Photography is perceived like writing, as subjective, capable of insight. This will make many of us happy. But its fact-based, mechanistic qualities, which have been able to change world opinion even against the most powerful governments, have been devalued to the point where photography is much less a threat to established points of view. The debate encouraged by the photographs of the Vietnam War will probably not occur again. Photography becomes poetry, and those whose position is less than lyrical suffer the most. How many poems in recent years helped to affect the course of world events the way Eddie Adams's photograph of the point-blank execution of a member of the Viet Cong did?

It was the most visible of times, and the most invisible.

Karin E. Becker

to.c

our im

photojournalists meetin

new technology

Karin Becker received her Phd. in Mass Communication from Indiana University in 1975. Since then she has been teaching and conducting research on the culture of photojournalism and documentary photography, both historically and in contemporary settings. Her book *Dorothea Lange and the Documentary Tradition* (Louisana State University Press, Baton Rouge, 1980) has been followed by numerous articles, including most recently, an analysis of US photojournalists' attitudes towards technological change, and an examination of photojournalism in the western tabloid press. Karin Becker lives in Stockholm.

The new technology has the potential of undermining our faith in photography as a reflection of reality.

Edward Klein, editor, *New York Times Magazine*, 1985

ontrol
age

This article appeared in *Media, Culture and Society,* vol13 no3 1991

Facing the impact of new electronic and computer technologies, photojournalists are reconsidering the nature of the photograph as document, the ethical guide- lines of their work, and their roles and responsibilities within news organizations. An analysis of the National Press Photographers' Association official publication, *News Photographer,* 1980–8, found that US photojournalists interpret four areas of innovation as challenges to the boundaries of their work: colour photography in the daily press; the digitization of the photographic image; the still-video camera; and new technologies of image transmission.

The magazine's treatment of each innovation is examined, and strategies are then identified that the field uses to reassert its members' sense of control over innovation. These include modifying news photography contests, testing innovations during major news events and using language that asserts photo- journalists' power in the news organization and refers to accepted practice and values. Control becomes an ethical issue, needed to preserve photojournalism's status and to safeguard the credibility of the photograph as a document of reality.

Photography and news in the new media age
- a framework

Because the photograph both imitates and reconstructs the world, we treat it simultaneously as 'natural' and 'cultural'. Our belief in the photograph as a picture of the world as it existed for one moment in front of the camera's lens remains deeply imbedded in the cultural history of photography. At the same time, the 'truth' we construct from the camera's image is continually qualified, modified and challenged by our various understandings of the cultural and political work the photograph is being asked to perform.

Photography's development and spread during the second half of the nineteenth century occurred at a time when the value of the fact was on the rise. The notion of the photograph as record, evidence and proof resonated profoundly with new institutions of science, government and industry in many western lands.[1] William Ivins, in his ground-breaking work on the development of pictorial communication, traces the adoption of the photographic image as the norm of representation: 'The nineteenth century began by believing what was reasonable was true and it wound up by believing that what it saw a photograph of was true.'[2] Journalism was among the first institutions to identify itself with photography, exploiting the belief in the photograph as an accurate, credible representation of reality. Several decades before photographs were printed in newspapers, the repertorial convention of objectivity took root, and it was common in the British and American press to find references to the reporter as a 'mere machine' recording the 'exact truth', and to the camera as a metaphor for the reporter's activities.[3] Illustration remained tied to cumbersome engraving techniques until the invention of the halftone process in the 1880s, but in the meantime, a drawing's veracity was often authenticated by the credit line 'from a photograph'. Today the ideal of objective journalism, its roots intertwined with nineteenth-century beliefs about photographic realism, lives on as an occupational ideology. Although the camera is no longer the journalist's guiding metaphor, the news form continues to be shaped by professional attitudes that closely correspond to assumptions about photography's ability to 'tell the truth' in unbiased, accurate accounts of world events.

Photojournalism is the one branch of the profession where the explicit link persists between the ideology of objective news reporting and the camera as the tool ideally suited to the task. Photography has always been dependent on technical, optical and chemical procedures. Photojournalists – those journalists who report the news through the medium of photography – combine these procedures with strategies that are intended to uphold the culturally negotiated standards of the journalism profession. Within this framework, technology at times broadens and at other times restricts their access to news. For example, in

the late 1920s, 35mm cameras with faster film and lenses enabled German photojournalists to work more unobtrusively using only available light. They soon developed strategies for going 'behind the scenes' to make candid photographs of subjects that previously had only been reported in words.[4] Yet, in a counter example, the camera's presence in US courtrooms has been severely restricted, based on the presumably disruptive effect of the technology, and the publicity that photography was thought to bring to trial participants. While reporters with notebooks and sketchpads were admitted, the photojournalist's work was seen as violating conditions for a free trial.[5]

Technological innovation is persistent and continuous within photojournalism. No other journalists face the same degree of change in the tools they use for gathering, processing, selecting, editing and distributing news. Historically this has meant that photojournalists are repeatedly challenged to adjust their work strategies to technological change, while remaining true to existing standards of journalistic practice. Conflict frequently arises, and a process of renegotiation begins, resulting in change both in the work strategies and the stated journalistic standards.

The past decade provides a fruitful framework for examining how this group of journalists accommodates technological change. Facing the impact of new electronic and computer technologies, photojournalists today are reconsidering the nature of the photograph as a document, their ethical guidelines and their roles and responsibilities within the structure of news organizations. Such discussions suggest that photojournalists are constructing new boundaries to define and defend the status of their work in the new media age.

The photojournalists' discourse

One important site of these discussions is in the pages of *News Photographer* (*NP*). The official monthly publication of the National Press Photographers' Association (NPPA). There is no union for US press photographers; NPPA has served as their primary source of information and support since its founding in 1946.[6] *NP* is the photography magazine most frequently read by US photojournalists, including many who are not members of NPPA.[7] Written and edited by press photographers, picture editors and managers and directors of photography at US newspapers and news magazines, *NP* is a forum for information and issues that affect both day-to-day work and the broader goals of news photography.

The present study is based on the text of the magazine from 1980 through 1988, and fieldwork conducted between 1979 and 1983 among the photography staff of four metropolitan daily newspapers in the United States.[8] The questions guiding the analysis are: first, what issues become important for discussion among

1. John Tagg, *The Burden of Representation*, Amherst, University of Massachusetts Press 1988

2. William M. Ivins, Jr, *Prints and Visual Communication*, Cambridge MA, MIT Press 1953 p94

3. Dan Schiller, 'Realism, Photography, and Journalistic Objectivity in 19th Century America', *Studies in the Anthropology of Visual Communication*, 4(2) 1977 pp86-98

4. Karin E. Becker, 'Forming a Profession: Ethical Implications of Photo-journalistic Practice on German Picture Magazines 1926-1933', *Studies in Visual Communication*, 11(2) 1985 pp44-6O

5. For a review of the National Press Photographers' Association's role in this long and complex negotiation, see Claude Cookman, *A Voice is Born*, 'The Fight Against Canon 35', National Press Photographers' Association, Durham, NC 1985 pp149-73. For a thorough recent review of the courts' limitations to electronic (including camera) coverage, see Carolyn Stewart Dyer and Nancy R. Hauserman 'Electronic Coverage of the Courts: Exceptions to Exposure', *The Georgetown Law Journal*, 75(5) 1987 pp1634-700

6. A 1983 national survey found that 69 per cent of photographers employed by daily newspapers in the United States belonged to NPPA (Beverly Bethune, 'Under the Microscope. Special Report', *News Photographer*, 38(11) 1983). A majority of its 8000 members participate in no other professional organization

7. Bethune, op.cit.

8. A report of this fieldwork appears in Karin Becker Ohrn, 'How Photographs Become News: Photojournalists at Work'. Paper presented at the Association for Education in Journalism and Mass Communication Conference Corvallis, Oregon 1983

photojournalists facing new technologies, and in what terms are these discussed? Then, how do the issues become resolved: do the discussions result in a redefinition of their work? And equally important, are there issues that are not raised for discussion, but remain in the background as unquestioned assumptions regarding the nature of the field?

The emphasis here is not on the effects of technology on some journalistic product, nor on the receivers of that product. Instead, the focus is on the occupational group most affected by the technology. Any broader 'effect' within the public sphere is mediated by the understandings and applications photojournalists create for the new media. Analyzing photojournalists' discussions, one learns how they interpret the technology's impact on their work and on the broader sphere of photography's role in public life.

Technological innovation becomes an explicit topic in *NP* when it is regarded as affecting the quality of photojournalistic coverage or the boundaries and definitions of photojournalists' work. Innovations vary, of course, in the degree and nature of their perceived impact. How they are identified and discussed in the magazine – the terms used, the professional issues that are identified and, in the case of a conflict, where the conflict is located and how it is framed – indicate how the innovation is expected to affect photojournalism. In cases where the photojournalistic discourse treats technological innovation as a challenge to its principles, one finds the assumptions that support photojournalism as a profession and that in turn shape photography in today's press.

Four areas of innovation emerged from the *NP* discourse as issues affecting the definitions and boundaries of the field: colour photography in the daily press; the digitization of the photographic image; the still video camera; and new technologies of image transmission. Each of these areas of innovation is presented and analyzed in turn, examining how it has been used, argued and defined within this photojournalistic discourse. As the meanings of each innovation emerge, certain patterns also appear, strategies of control common to the photojournalists' negotiation of all four areas of innovation. Photojournalists appear to use these strategies to resolve ambivalence about innovation and thereby reassert a sense of control over the parameters of their work. Both the strategies used in this renegotiation and the resulting boundaries – whether redrawn or simply reasserted – are central to understanding the changing relationships between photography and news in the new media age.

The credibility of colour

The expansion of colour photography in the 1980s initially did not appear to cause any substantive shift in photojournalism. Events previously photographed

in black and white were now covered in colour, while the topics and news values they reflected remained unchanged. Embedded in the move to colour, however, were some serious consequences for photographic reporting.

Colour first appeared on newspapers' daily and Sunday section-fronts, simultaneously with increased sales of colour advertisement pages.[9] *News Photographer* reported research on the public's preference for colour,[10] and published articles about newspapers increasing colour coverage. A 1984 survey revealed that daily newspapers across a broad circulation range regularly published colour news photographs.[11] However, the position of paid colour ads and the edition's size usually determined the use of colour, not editorial decisions about when and where it served the best journalistic purpose.[12]

Photojournalists were often required to cover assignments with both black-and-white and colour film,[13] and complained of missing shots while switching cameras and of having good colour photographs on days their papers could not use them.[14] The narrower latitude and greater expense of colour also demanded different shooting techniques, including more carefully planned lighting and exposures.

Production capabilities were also influencing colour photojournalism. When the best photographs by journalistic standards were technically difficult to reproduce, conflict arose between photojournalists and production personnel. This phenomenon had long been routinized for black-and-white photographs; photojournalists knew how to accommodate both news values and production standards, and production staff could reproduce their work satisfactorily. While not conflict free, negotiations between photojournalists and the 'back shop' generally followed an established pattern. Colour, with its narrower latitude for error, disrupted the pattern; decisions previously made in the newsroom were being made by production personnel, and photojournalists were concerned over the loss of editorial control.

By the mid-1980s, the shift from colour transparencies to colour negative film had solved some production problems; when necessary, black-and-white prints could be made from colour negatives.[15] Automatic printmakers had also speeded up production,[16] and portable colour transmitters were in use, essential developments for colour coverage of major national and international news events. The 1984 Summer Olympic Games in Los Angeles became the first major test of colour photojournalism. Improvements in both quality and speed had increased the demand for colour projects, and no news event had ever been covered so extensively in colour: close to forty per cent of the Associated Press film of the games was colour, and the Orange County (California) *Register* (which won a Pulitzer Prize in photography for its Olympic coverage) shot 2500 rolls of colour film alone.[17]

In the meantime, news organizations were learning to adapt colour into their routine for covering late-breaking local news. Spot news – a bridge collapse in

9. *NP*, October 1981 p4

10. *NP*, November 1982 p2

11. *NP*, March 1984 pp16–18

12. *NP*, October 1982 p12

13. *NP*, March 1984 p14

14. *NP*, December 1983 p14

15. *NP*, November 1984 p46; February 1984 p11

16. *NP*, February 1984 p10

17. *NP*, November 1984 pp35–9

Hartford, Connecticut, and firestorms in Orange County, California, for example – pushed newspapers to find space and print colour on deadline.[18] Coverage of major news, both planned events and spot news, was giving photojournalists experience that enabled them to 'routinize the unexpected' and integrate colour into their work strategies.[19]

Colour's technical constraints also fuelled photojournalists' ongoing debate over the ethics of arranging photographs. Colour demands more attention to both the quantity and quality of light,[20] and it is difficult to control lighting without also asserting more control over the subject. Tighter production schedules and the related planning for colour section-fronts and other special projects, plus the additional cost of producing colour, all put pressure on photojournalists to arrange photographs. As they become more skilled and it became more difficult to recognize the 'set up' photograph (with lighting so 'natural', for example, the subject looks 'unlit'[21]), some photojournalists became concerned. As one picture editor expressed it, 'We're *making* more pictures than we're *taking*', and developing habits that threatened the credibility of the photograph as a news document.

Credibility was protected, however, if the arranged photograph clearly looked *constructed*, to distinguish it from photographs taken from 'real life'.[22] 'Photo illustration', a major development of the 1980s, was based on this distinction, stimulated by colour section-fronts featuring fashion, food and editorial topics difficult to illustrate with an unposed photograph. These were often elaborate studio arrangements, requiring several days of the photographers' time. Many photojournalists took great pride in these photographs they 'created', as distinct from the snapshot which depended primarily on 'luck'.[23] They were also frequently winning the NPPA's contests, where creative illustrations formed a growing part of the 'feature' category.

Others saw illustration as a threat to photojournalism. Photojournalists from smaller newspapers lacking sophisticated colour facilities found themselves at a disadvantage when they entered contests with their spontaneous black-and-white feature photographs.[24] The so-called 'enterprise' photograph, the result of a photographer's own ingenuity and luck, had long been the staple of the feature category. Contest judges, themselves newspaper photojournalists, expressed doubts about their selections, concerned that 'slick' colour illustrations over-shadowed the merits of black-and-white enterprise photographs.[25] After several years of discussion, NPPA created a new category for illustration 'to provide separate competition for images derived from life as it is observed (features) and images contrived by the photographer (illustration). The degree of influence the photographer has on the subject and setting' determined which category was appropriate.[26] This formalized the boundary which had been forming between illustration and feature photography, and reinforced the status of photographs 'from life as it is observed', as worthy photojournalism. The new contest rules did not, however, resolve the status of illustration, or as one photographer put

it, 'the squabble between real pictures and fake ones'.[27] One judge criticized newspapers' demands for 'more illustration, more colour, and slicker images....[I]t takes away from fundamental photojournalism'.[28] Others affirmed her view that news and feature photographs, unlike illustration, are 'products of real events', and 'the fundamental purpose of photojournalism'.[29] New colour technology, and the concomitant changes in styles and work routines had brought about a reassertion of the traditional value of the 'real picture', the unmanipulated photograph of an actual event: these are 'our top priority', the 'fundamental photojournalism', while illustration is 'just MTV on a news page'.[30]

Dilemmas of the digitized image

The introduction of digital retouching further complicated the issue of photo illustration because it made it possible to retouch and synthesize new images with 'lifelike realism'.[31] In the industry this new computer technology had different names: electronic retouching, computer imagery, electronic colour imagery or just ECI. The process was based on a laser technology which screened the continuous tone photograph, translated it into digital data, then fed it into the computer. The photograph then could be displayed on a gridded video monitor that divided the image into minute picture elements, or 'pixels'. Any area of the screen could be enlarged for retouching, pixel by pixel. Possible manipulations included removing, cloning, deleting or combining parts of the image with other objects, and changing their colour and brightness.[32]

Digital retouching was usually much faster than reshooting a studio illustration, although the computer's time to produce the image could add several hours. Related technology soon made it possible to feed the retouched image directly into production or to transmitters for wire service distribution. Digital retouching had the potential to shift even greater control to the production department, and stories of editorial blunders and unethical practices began to circulate among photojournalists. At the Orange County *Register*, a photograph of a swimming pool that had been dyed red by vandals was 'corrected' in production so that the blue was restored in the paper's first edition.[33] The ethics of 'dialling in' a clear blue sky over the *Register's* Olympic coverage was also strongly criticized.[34] These problems were avoidable, it was argued, if the technology were in the hands of journalists. At the Providence (Rhode Island) *Journal-Bulletin*, the managing editor for graphics pointed out the his was one of only two papers in the US 'where *editorial* people are running the electronic page assembly and colour equipment...people with editorial values and ethics.[35] Elsewhere, strict limits were set on electronically 'improving'

18. *NP*, October 1982 p8; December 1988 pp6-8; January 1984 pp6-7

19. Gaye Tuchman, 'Making News by Doing Work: Routinizing the Unexpected', *American Journal of Sociology*, 79 1973 pp110-13

20. *NP*, August 1984 p32

21. *NP*, January 1987 p38

22. *NP*, January 1987 p40

23. *NP*, January 1982 pp43-4

24. *NP*, January 1985 pp39-40; June 1986 pp43, 45; August 1986 p58

25. *NP*, March 1985 p33; February 1986 p42

26. *NP*, April 1987 p6; September 1986 p16

27. *NP*, September 1986 p38

28. *NP*, June 1987 pp28-9

29. *NP*, June 1986 p45

30. *NP*, September 1986 p39; June 1986 p45

31. Sheila Reaves, 'Digital Retouching', *News Photographer*, 42(11) 1987 p23

32. Reaves, op.cit. p24

33. *NP*, January 1987 p34

34. *NP*, April 1986 p39 January 1987 p40

35. *NP*, January 1987 p29

photographs and procedures were established for conveying editorial decisions to production personnel.[36] Photojournalists were also urged to become involved in management: 'The introduction of electronic scanners and digital retouching is another reason for "strong photo management involved in the highest levels of decision-making at newspapers".'[37]

No one asserted that photojournalists should be creating only 'straight' or unmanipulated prints. Instead the photographer's autonomy and authority to alter the image was stressed – within the established conventions of photojournalism. Accepted darkroom practices for black-and-white photographs were referred to when drawing limits for digital retouching. The *Chicago Tribune* would not use the computer to reverse a photograph or to drop out a background, but would 'burn and dodge', 'like you do a black-and-white print'. The director of photography at *USA Today* said, 'We do no more with our colour than we do with black and white – that's colour correction and making it printable'.[38] Technological innovation at the Associated Press required no change of their standing policy: 'We don't tamper with pictures'.[39] The traditional rules were still in place; the new technology enabled photojournalists to do no more than they had always done, only better and faster.

Yet photojournalists were making distinctions between the kinds of photographs to which the old rules applied. While 'news' photographs should never be altered (beyond burning and dodging or cropping to give the subject greater emphasis), many saw feature photographs as permitting greater latitude, including digital retouching. Some drew the line at photo illustration, the obviously arranged studio photograph. Others went further, to include removing 'clutter' from the background of a 'real' scene in a feature photograph. Still others thought the key factor was the location of the published photograph: digital retouching may be appropriate on art and entertainment pages,[40] or for a cover photograph. Rick Smolan, who organized several photojournalism projects covering 'A Day in the Life' of various countries, argued that a cover, unlike the inside photographs, serves as an advertisement for a book. Digital alteration is a legitimate way to make the cover 'more dramatic and more impressive'.[41] At *National Geographic*, a pyramid was digitally moved for a cover story on the Egyptian desert in February 1982. Rich Clarkson, director of photography at the magazine, argued that no falsification had occurred since the photographer could have altered the scene in several acceptable ways when taking the picture, like 'moving' the pyramid by changing his position.[42]

Such cases have raised controversy, and photojournalists are far from a consensus on how the digitized image may be altered, if at all. Those who would allow it draw parallels with previous practice and/or construct boundaries around specific cases – features, photo illustrations, covers – where it may be used. Others would exclude it entirely from their work. All agree, however, that the invisi-

ble manipulations of digital retouching can impair the status of photojournalism and potentially destroy the credibility of the photograph as a document.

36. Reaves, op.cit. p30

37. *NP*, January 1987 p30

38. Reaves, op.cit. p27

39. *NP*, January 1987 pp33–41

40. Reaves, op.cit. p28

41. *NP*, January 1987 pp25–6

42. Reaves, op.cit. pp31–2

43. *NP*, November 1982 pp12, 14, 16

44. *NP*, January 1987 p35

45. *NP*, January 1987 p35

46. *NP*, November 1982, pp15, 40

47. *NP*, November 1983 p10

48. *NP*, January 1984 p5

49. *NP*, November 1988 p24; May 1988 p43

50. *NP*, November 1988 p24

Still video vs the photojournalist's craft

The electronic non-film still camera made its debut at an engineering conference in 1982.[43] Four years later at the Photokina conference in Cologne, ten manufacturers displayed versions of the still video camera. Most were interested in the mass market, but photojournalists saw the camera as 'an important key in the electronic puzzle' they were piecing together.[44]

Designed to operate much like a conventional 35mm camera, still video uses a charge-coupled device (CCD) as the imaging sensor, and records onto a disk which holds twenty-five to fifty images, depending on whether the camera is operating in 'frame' or 'field' mode. A frame image, which takes up two fields, gives better resolution – more than 250,000 pixels. At 350 lines per inch, the quality was still low by newspaper standards; 750-800 lines would have been 'pretty good'.[45] The appeal of the new medium lies in its immediacy; the image is projected and edited directly on a video screen, eliminating all the time-consuming chemistry of the darkroom.

The electronic image blurred the line between television and newspaper photography. Photojournalists were already uncomfortable with the practice of publishing stills from television, even when television coverage was better or all that was available.[46] In a compelling exception, the 1982 Pulitzer Prize in photojournalism was nearly awarded to a television cameraman. The jury of five still photographers recommended unanimously that a still from Charles Panzer's videotape of a dramatic rescue from a plane crash in the Potomac River should receive the award. The image had been transmitted by the Associated Press and published in many newspapers. Any arguments against giving Panzer the award were defeated, a juror explained, when one recognized that future photojournalists would be using still video.[47] The Pulitzer Prize Board made a different selection, however, and the following year clarified its policy: stills from television were eligible for the competition, but 'in all cases, preference will be given to work appearing first in newspapers'.[48]

Photojournalists continued to echo this ambivalence toward electronic images. A significant part of the photographer's craft takes place in the darkroom, and many were reluctant to give up 'the magic of watching an image slowly appear' and 'the satisfaction of hand burning and dodging a special picture'.[49] Yet, freed from the darkroom, photojournalists could 'spend more time and energy in our jobs as journalists',[50] 'more time being news people, news gathering, and less

time as lab technicians'.[51] This meant 'time to research and think through what they're trying to do and prepare for the assignment'.[52] Time in the darkroom, in other words, is time *away* from journalism.

Eliminating the darkroom, however, would also decrease the photographer's control as more decisions over image selection and editing would occur in the newsroom. Some saw this shift of responsibility as positive, because 'the picture desk person will need to be more of a photographer, and photographers will have to think more like an editor'.[53] Predictions varied on how soon such effects would be felt and when, if ever, film-based technologies would be eliminated from photojournalism.[54] The deciding factor would not be the photojournalist's responsibilities, however. Instead it was the balance between the immediacy of the technology and its low image quality which determined the 'special situations' for still video's use.[55]

Those special situations have been spot news stories of national interest occurring on deadline. Still video images from a World Series baseball night game in October 1987 were transmitted over telephone lines for *USA Today's* front page the next day. Although 'the quality wasn't terrific', film would never have made the newspaper's deadline.[56] The 1988 Democratic Party conventions gave the Associated Press its first opportunity to transmit an all-electronic photograph. When the convention hall was closed by fire officers during a key session, no photographers could get their film out for processing. The AP used a still video camera connected by cable to their 'electronic darkroom' to photograph Jesse Jackson introducing Rosa Parks, heroine of the Montgomery bus boycott. The photograph was ready for transmission twelve minutes after the camera's shutter was released. The image was weak – 600,000 pixels compared to 2.7 million for a conventional wire photo – but it demonstrated the technology's utility,[57] when transmitting photographs quickly was more important than image quality.

Transmitting from 'the walking tripod'

The still video camera became a tool for gathering news only when its images could be moved rapidly to the newsroom and transmitted quickly for publication. As long as press photographs continued to be made on film, the immediacy of a camera-ready-to-newsroom cable connection was impossible. In the meantime, however, electronic technology had been simplifying the movement of images, both film-based and electronic.

Transmitters which scanned negatives for sending over telephone lines eliminated the need for prints. And briefcase-sized portable transmitters were introduced at sixty Associated Press newspapers early in 1988.[58] The new trans-

mitters enabled photojournalists to format, caption and transmit 35mm black-and-white or colour film directly to computers or output printers. They saved time, produced sharper images than conventional transmitters, allowed for some colour correction in the field, and enabled photojournalists to travel with less equipment.[59] The portable units had obvious advantages for out-of-town assignments and for major news events where the volume of photographs was high.

The next link in the process was the electronic darkroom, or electronic picture desk as it was variously called, where the photograph could be stored or recalled for further editing. Generally its capabilities included changing contrast, enhancing and cropping images on a video screen. The electronic units that the Associated Press introduced in 1987 could digitally correct colour separations, produce positive prints, or be used as front-end systems for page layout and pagination.[60] There were disadvantages, too; editors found that storage capacity was often inadequate, especially on weekends or when major events generated lots of photographs. Because of the amount of space required to store digitized images, recalling and editing the images could also be slow.

Several major events of 1988 provided opportunities for crucial tests of the electronic transmitters. The Associated Press covered the Democratic and Republican Parties' national conventions and the Summer Olympic Games from Seoul without producing a single photographic print for transmission.[61]

Although the technologies for electronically editing, transmitting and storing images are not fully developed, photojournalists think the implications are clear. Increasingly, transmission systems will become digital, vastly increasing their speed. The new systems will also shift responsibilities of selecting and editing photographs away from the photographer.[62] Two factors are considered critical in this vision of photojournalism's future: one is the difference between the electronic and the film-based image; the other is the responsibility for photographs within the news organization.

The electronic image, unlike film, leaves no trace of the changes performed on it. This presents a challenge to the standards of photojournalistic practice that include fidelity to the image the photographer took and guidelines for altering that image. 'Now we have an acetate base – we have the original to judge from', said one director of photography. But the electronic image eliminates the possibility of catching any changes that violate the guidelines because the original image, the standard of 'reality', is gone.[63]

Within the news organization, the new technology may eventually have greater impact on the picture editor's job than on the photographer. Many photojournalists think that the photographer will continue to take, or make, photographs, while the person at the picture desk will make far more of the decisions regarding which photographs will be used and what they will look like. This will require the picture editor 'to be more of a photographer, able to judge the moment'.[64]

Historically the most common route to an editor's job has been through the

51. *NP*, May 1988 p43
52. *NP*, April 1984 p14
53. Ibid.
54. *NP*, June 1988 pp19-20; November 1988 p24
55. *NP*, June 1988 pp19-20; November 1987 p27
56. *NP*, January 1988 p43; June 1988 p20
57. *NP*, November 1988 p28
58. *NP*, June 1988 p20
59. *NP*, June 1988 p44; May 1988 p45
60. *NP*, November 1984 p39; November 1982 p44; February 1988 p10
61. *NP*, November 1988 p23
62. *NP*, March 1984 p18
63. *NP*, January 1987 p32
64. *NP*, April 1984 p14

'word side' of the newspaper, and many of the people sitting at picture desks have had little prior experience in photojournalism. Photographers fear that, with the added power electronic technology brings to the picture desk, photojournalism will be shaped increasingly by people who are 'visually illiterate'.[65] They believe that many editors 'just don't consider *visuals* as potent as written words' or 'can't recognize a visual ethical problem'.[66] Against this background, electronic technology implies more than a loss of power for the photojournalist. At stake is also the credibility of the photograph as a news document, even the public's trust in all photography'.[67]

Those who welcome the future of electronic image transmission see it as integrating the photojournalist's work more closely with the rest of the journalistic enterprise. The integration will be complete if, or when, the images the photographer takes with the camera are seen simultaneously in the newsroom. At that point, the photojournalist becomes comparable to the reporter, who already has the electronic means to transmit stories back to the newspaper.[68] And, freed of the darkroom, the photojournalist can spend more time researching and gathering news.

In the alternative view, the technology will reduce the photojournalist to a mere technician, blindly following instructions from an editor who looks at the image on the monitor and guides the camera – 'pan a little to the right, a little lower, there!' – to take the picture that will be published. This is the photographer as the 'walking tripod', whose journalistic skills and experience have been completely bypassed by the electronically transmitted image.[69]

Controlling change

Ambivalence permeates photojournalists' discourse on these technological innovations. An innovation is seen either as a liberating opportunity or a threat to the photojournalist's status, depending primarily on photojournalists' sense of control over the technology. Implementing an innovation thus includes procedures for negotiating its control. To this end, the photojournalism profession has developed strategies for situating and naming change that serves to resolve ambivalence by defining an innovation's place within a framework accepted by members of the field. Contests are an important way that this occupational group names its leaders and identifies trends. The NPPA's carefully monitored system of monthly, annual, regional and national competitions is also a significant site of challenge and debate between established conventions of photographic reporting and path-breaking innovation. The outcome of these struggles – the contest winners, new rules and procedures – control the direction and meaning of the change. We saw, for

example, how the conflict between colour illustration and traditional concepts of black and white photojournalism was negotiated through NPPA's 'Monthly News Clip Contest'. The Pictures of the Year contest changed its entry requirements from prints to slides in 1986, in part to accommodate the large number of colour entries and the cost of colour printing.[70] The 1983 Pulitzer Prize competition was the site of discussion about accepting television images of photojournalism, and a reassertion of the primacy of the newspaper photograph. The winners of these competitions are treated as leaders; their comments on their work, as well as the judges' commentary, help to define the applications and meaning specific technologies have for the field as a whole.

Events reported as major news stories are also occasions for testing and defining new technologies. These events can be divided into two types, requiring different strategies of coverage. One is the scheduled national or international event, which is planned and co-ordinated long in advance. The second type is unscheduled and unexpected, a disaster or accident that may also have national or international consequences.

The scheduled event allows, even requires, advanced planning for coverage, including the technology to be used. Because of its visibility and significance, the event also provides a stage for demonstrating new technologies. At the 1984 Summer Olympics, for example, 'the big thing was colour':[71] the volume of colour film shot by news media was said to have surpassed all previous events, the Associated Press used portable colour print transmitters for the first time on a big story, and the local newspaper used its new colour facility to win the Pulitzer Prize. Canon chose the 1986 Pan American games to test, successfully, its still video camera.[72] The Associated Press used the major events of 1988 to break ground for electronic coverage, and boasted that 'the Democratic National Convention represented the first time a story of this magnitude had been handled electronically without the installation of a chemical-optical darkroom'. The Republican Party convention and the Summer Olympics in Seoul provided repeat performance for their 'electronic darkroom' and portable transmitters. The wire service immediately announced that in 1992, the 'next round of political conventions and Olympics' would be dominated by the electronic camera and transmission of digitized images.[73] News organizations have high demands for coverage of such major events. If a new technology proves able to provide rapid and comprehensive coverage better than competing technologies, its place in photojournalism has been secured.

The major accident or disaster occurs without warning. Competition for immediate on-the-spot coverage is extremely high and advance planning for coverage is usually impossible. Getting photographs from these classic spot news events usually requires ingenuity under extreme time pressure. News organizations cast a wide net to find photographs, and if none come in from the usual sources, they look elsewhere. Thus still frames from television have become

65. *NP*, October 1982 pp43-4

66. Reaves, op.cit. p32

67. Ibid

68. *NP*, April 1984 p14

69. *NP*, September 1986 p18

70. National Press Photographers' Association, *The Best of Photojournalism 12*, Philadelphia, PA, Running Press 1987

71. *NP*, November 1984 pp38-9

72. *NP*, November 1987 p28; January 1988 p43

73. *NP*, November 1988 pp21-2

major news photographs when no film of an event was available. The demand for immediacy can, as in these cases, contribute to a technology's acceptance.

More commonly, however, the spot news event presents a sudden challenge for testing a new technology. A newspaper with new colour capability may push aside a strict production schedule to get front page colour coverage of a late-breaking story. The new portable colour transmitters gave same-day coverage to newspapers faced with the logistics of transporting film out of Yellowstone National Park during the forest fires of 1988 – as long as their photographers could get a telephone installed for transmissions.[74] In spot news the new technology meets a major test, often requiring radical adjustment of previous routines. Time pressure and competition highlight problems, and ways are then found to solve them. If a technological innovation proves successful, it will be used again, with greater confidence and finesse. The spot news event thus helps establish new routines that include the innovation in future coverage.

Once a new technology is integrated into the routines of covering both planned and spot news events, its continued development and use is seen as unavoidable; the competitive demands of the field prevent turning back. This acceptance and control of the technology at the practical level of day-to-day work routines does not always resolve photojournalists' ambivalence, however.

Because technological innovation affects the structure of decision-making at many newspapers, photojournalists are concerned about how such changes affect their control over their work. Job security *per se* is rarely mentioned; photojournalism's status is the more common way of framing the issue. Moving 'out of the darkroom and into the newsroom' is advocated as one way to reassert editorial control over photojournalism. As electronic technology eliminates the darkroom, photographers can devote more time to the journalistic aspects of their work, which will also make them better photojournalists. Moving up in the hierarchy of the newsroom is also implied, into positions of greater control over assignments, editing, selection and production.

The language that defines a higher status for photojournalists within the news organization may in itself be a strategy to enhance their sense of control over technological innovation. It is not clear that changes in organizational structure have taken place. Photojournalistic training for picture editors is stressed, and scholarships and workshops in picture editing have been offered. Yet the directors of photography and managing editors who are frequently quoted in *News Photographer* usually have long held positions of relative power. Conferences and workshops on topics related to new technology are frequent and well attended, but staff photographers often feel the political realities of their positions go unaddressed. Newspapers that have adopted new technology report establishing 'guidelines' for the technology's implementation that protect photojournalism's status, but rarely mention major staff reorganization or new lines of authority.

The language photojournalists employ to discuss new technology is also

reassuring in its emphasis on accepted tools and techniques. The computers 74. *NP*, November 1988 p45 are called 'electronic picture desks' and 'electronic darkrooms', recalling familiar functions. Techniques of digital retouching are legitimized by referring to traditional ways of arranging and altering news photographs: 'changing camera angle', 'burning and dodging', 'using a filter'. Change is made familiar through language that reasserts accepted practice and refers to basic values. Thus ambivalence is resolved in favour of an innovation when photojournalists can interpret it as helping them to work as they have always done, only faster and with better results.

Conclusions

Photojournalists see themselves as responsible for establishing and maintaining the standards of photography in the press, and without their photographs, press representation of the news would be incomplete. We have seen how photo-journalists have responded to technological innovations of the 1980s by reasserting the importance of their place in the journalistic enterprise and the significance of the photograph as news document. These reassertions arise from a process of negotiating the meaning technology has at different levels of photojournal-ism: the day-to-day work routines, the status of the work within the news organization and within journalism as a whole, and the continued credibility of the photograph.

Photojournalists assert that the public's belief in their work is essential, and that their credibility depends on the public's ability to trust in their photographs as unconstructed 'pictures of reality'. New technologies threaten to undermine this trust by blurring the visible distinction between the manipulated and the 'real' image. Ethical guidelines are drawn up in order to clarify once again this distinction and to apply it to the production of the news photograph. Photojournalists' control over the technology thus also becomes an ethical issue, not only to preserve their status within journalism, but to protect the integrity of the photograph itself.

In response to technologies that appear to alter the very base of the photo-graphic medium, photojournalists have reasserted their belief in the value of the photograph as a document of reality. In so doing, they have revealed that the concept of photographic truth remains deeply embedded in the professional culture of photojournalism.

Philip Benson
David Perrett

compu
and man
faces

Philip Benson is a computer
scientist (image synthesis and
animation) and researcher in
Visual Neuropsychology at the
University of St Andrews, Fife.

David Perrett is a physiologist
(neural computation and
anatomy), a lecturer in
Psychology and a researcher in
Visual Neuropsychology at the
University of St Andrews, Fife.

Both hold common research
interests in the higher-order
processing of visual
information, particularly in the
coding of faces and their
attributes, in memory.

Areas covered include the
perception and recognition of
facial identity and its
manipulation in caricature,
the visual components of age,
gender, attractiveness
and the applications of facial
transformations in
forensic science
and telecommunications.

With the assistance of Sir Edmund Du Cane, HM Director of Prisons, Galton attempted to define the facial attributes of people with criminal tendencies. He averaged together the photographs of criminals drawn from a sample of those convicted of murder, manslaughter, or violent robbery. Perhaps to his surprise, he found that the composite tended to look more respectable than the faces that had been averaged together.

averaging

ulation of

This work was supported by awards from the ESRC (XC15250005) and the SERC (GR/F97591)

An officer and gentleman, or a handsome criminal

Composite photography has its origins in the latter part of the nineteenth century with the experiments of Galton.[1] This process involves the photographic superimposition of two or more faces by multiple exposures. Two faces can also be combined perceptually (though not very well) with each eye viewing a separate image in a stereoscope. For the technique to work, the original facial images must be of the same size, pose, have features of similar dimensions, and must be carefully aligned so that the eye pupils are coincident. If these conditions are met, then the composite, or average, maintains a resemblance to a human face, indeed it actually looks like a real person, yet it appears different from the faces on which it is based!

Galton reasoned that the composite technique could be used to define the facial characteristics of particular social classes and types of people. He believed that the characteristics common to individuals of one category would be maintained in a composite of faces from that category, the idiosyncratic variations of particular individuals being averaged out.

Galton attempted to define facial or physiognomic characteristics of health (by combining faces of army personnel), disease (victims of consumption or tuberculosis), and criminality (convicted criminals).

With a sample of Officers and Privates from the Royal Engineers, Galton took it that all possessed the 'bodily and mental qualifications required for admission into their select corps'; he therefore assumed the composite made from the faces of such an upstanding selection of the community would display the facial qualities of 'health'. In his eyes, the composite depicted a face 'having an expression of considerable vigour, resolution, intelligence and frankness'.

With the assistance of Sir Edmund du Cane, HM Director of Prisons, Galton attempted to define the facial attributes of people with criminal tendencies. He averaged together the photographs of criminals drawn from a sample of those convicted of murder, manslaughter, or violent robbery. Perhaps to his surprise he found that the composite tended to look more respectable than the faces that had been averaged together; 'the special villainous irregularities

Figure 1

in the latter composite have disappeared, and the common humanity that underlies them has prevailed'. Even so, Galton felt that the composite displayed an individual of a 'low type', a 'man who is likely to fall into crime'.

The face of coalition

Galton used his composite portraiture to obtain images of historical figures by combining portraits from different artists. An example of his work is shown in figure 1 (top left) where he derived a composite medallion of Alexander the Great by photographically blending six different medals. He argued that the composite would be a truer likeness since irregularities introduced by different artists would average out. He commented that a composite portrait of Cleopatra made in this way, though more attractive than the original portraits, still did not 'give any indication of her reputed beauty; in fact her features are not only plain, but to an ordinary English taste are simply hideous'.[2]

Whereas artists have produced many portraits of historical figures in standardized poses (e.g. full frontal or profile) the same is not true for current day celebrities. For these individuals, photographers capture a wide range of expressions and poses. Even with this variety, the computer averaging process can be used to derive an average image of one person in the same manner as that of Galton.

In figure 2 we have blended together the faces of all the Prime Ministers since Winston Churchill. In describing the resultant image of the 'average Prime Minister' we can best reiterate Galton's description of his blended portraits of criminals 'that the common humanity that underlies them has prevailed'.

An appliance of science: computer composites

In each of Galton's composite photographs very few of the facial features appear sharply focused with well-defined edges. The eyes appear most clearly, because in the original alignment of the images the distance between eyes was standardized across faces. The length, width and overall shape of noses will deviate amongst a sample of faces, some noses being fatter or thinner than others. Therefore, in the composite, the edges of the nose becomes blurred in accordance with the shape variation within the sample. More extensive blurring occurs around the jaw and hair-lines where individual differences are greater.

In computer graphics, images are displayed and stored as a regular array of image picture elements or pixels (typically 512 rows and columns). Each pixel has an associated intensity value and is equivalent to the individual grain of film emulsion in a photographic image.

Langlois and Roggman have recently used graphics to improve the composite technique of Galton.[3] They manipulated the dimensions of each face making up the composite in two ways. Each facial image was first adjusted in overall size and orientation such that the pupils of the eyes were aligned, images were then distorted vertically so that the distance between the eyes

Figure 1: Composite photographs made by Galton
By taking multiple exposures of several portraits, Galton was able to produce photographic composites for different social classes and types of people. The blends often looked more attractive than the constituent images due to the irregularities of the skin being averaged out.

Figure 2

and the centre of the top lip was equal across the faces. A composite face was then generated by averaging together the intensity values of corresponding pixels from the stretched images. In accordance with the technology the results were better than those of Galton's but still suffered from a degree of blurring of the facial features. This is because even when the separation of the eyes and mouth has been standardized, the shape and position of other features continues to vary.

The clarity of facial composites created in these ways depends entirely on the choice of starting images. For example, a set of faces with a high degree of variance in jaw shape unavoidably creates a composite with a fuzzy or blurred jaw-line. In fact, every feature will exhibit some degree of blurring. Hairstyles are extremely varied these days so a simple, composite image tends to show an unnatural ghosting around the hairline. Galton's average criminal may look likely to commit a crime (figure 1) because of the swarthy 'unshaven' appearance but this probably occurs because Galton blended bearded and clean-shaven felons.

To avoid blurring we have used computer graphics to manipulate face images more extensively before combining them to form a composite.[4] The shape of each face is first defined as a series of some 200 co-ordinates marking the outline of each facial feature. For ease of comparison across faces, the feature co-ordinates are referenced to a standard point on the face, halfway between the eyes. The shape of the prototype face for the sample is defined by calculating the average position of each of the feature markers across all of the original faces. The original facial images are then distorted to take on the shape of the prototype or sample average and finally the distorted images are blended together.

To visualize the process, imagine a thin sheet of patterned rubber pinned out on a flat surface; if the pins were dragged to new positions the shape of the pattern on the rubber will become systematically distorted. In the same way, the shape of each individual facial image is modified before blending. In essence the shape and position of each facial feature is distorted such that it exactly matches the proportions of the corresponding feature in the prototype face.

Averaging a sample of images of individual faces whose configurations have been regressed into a single prototypical shape produces a clear facial composite with well-defined edges. This technique forms the basis of the effects described in this chapter.

Sex

We have used the face-blending process to investigate the differences between male and female faces. Using the same logic suggested by Galton, it could be hypothesized that the blending of male and female faces separately would reveal the consistent differences between the sexes. If there are consistent differences in the shape of the average male and female faces (and these differences are important in controlling perception of gender) then exaggerating these differences or deviations in shape should enhance the apparent masculinity or femininity.

To test these predictions we blended together the faces of sixteen female students to create an average female student (figure 3b). The process was repeated separately for sixteen male faces to

Figure 2: Middle of the road?
A composite image of all the Prime Ministers between 1945 and 1991; including Churchill, Attlee, Eden, Macmillan, Home, Wilson, Heath, Callaghan, Thatcher and Major.

create a corresponding male prototype (figure 3d). Averaging the entire set of sixteen male and sixteen female faces together produced a prototypical student with an androgynous face that should be neither masculine nor feminine (figure 3c).

To create a 'hyper-male' face the differences between each feature point in the average male and female faces are doubled. If the tip of the male nose was ten units longer than the female nose, then in the hyper-male configuration the nose length was exaggerated so that the tip was twenty units longer (figure 3e). To create a 'hyper-female' face (figure 3a) the nose was shortened in length so that it was twenty units shorter than that of the average male nose (and thirty units shorter than the hyper-male nose). This process was repeated for all features (eyes, nose, mouth, jaw, etc.). The pixel images of average male and female faces were then distorted into their two hyper-sex configurations. To determine the role of the internal facial features in the perception of gender, a mask was placed around all the faces to remove cues from the hair and hairline.

The effectiveness of the manipulations was assessed by independent ratings of the apparent masculinity or femininity of the images. Perhaps not surprisingly, the average male was rated more masculine and the average female more feminine than the androgynous face. Further-more, the androgynous face was perceived as neither masculine nor feminine. What is exciting is the confirmation that enhancements of gender differences actually work. The 'hyper-male' was rated more masculine than the prototype male. Similarly the 'hyper-female' was rated more feminine than the prototype female.

What this has shown is that, on average, the shape of the internal features of a face are sufficient for accurate judgments of gender. Hair, which is often a powerful cue to sexual identity, need not be considered.

The demonstrations revealed basic structural differences between the sexes for the population of students studied. From the illustrations of figure 3, male noses tend to be longer, nostrils more protuberant, whole face larger, eyebrows thicker and jaws squarer. There are also more subtle differences apparent in the shadows caused by the cheeks.

Some of these observations have been noted before. Enlow argued that differences in the nasal and orbital regions of the face may have ecological significance reflecting adaptations of the respiratory system (since males have larger lung capacity).[5] In former times the physiognomists such as Lavater attributed the sexual dimorphism in nose and eyebrow shape to differences in male and female personality. 'Compressed, firm …[eyebrows]…are one of the most decisive signs of a firm, manly, mature understanding, profound

Figure 3: Gender enhancement using facial prototypes
All faces were masked so as to prevent the use of visual cues such as hair, neck, and ears. From the left (a) hyper-female; (b) average female; (c) androgynous face; (d) average male; and (e) hyper-male. Hyper-sex faces (a and e) were produced by exaggerating the shape differences between the average male and female faces (b and d). Enhancing sex differences altered perceptual ratings of masculinity/femininity. The hyper-female was judged more feminine than the average female face, and the hyper-male more masculine than the average male. The androgynous face (c), made by averaging male and female faces, was considered neither masculine nor feminine.

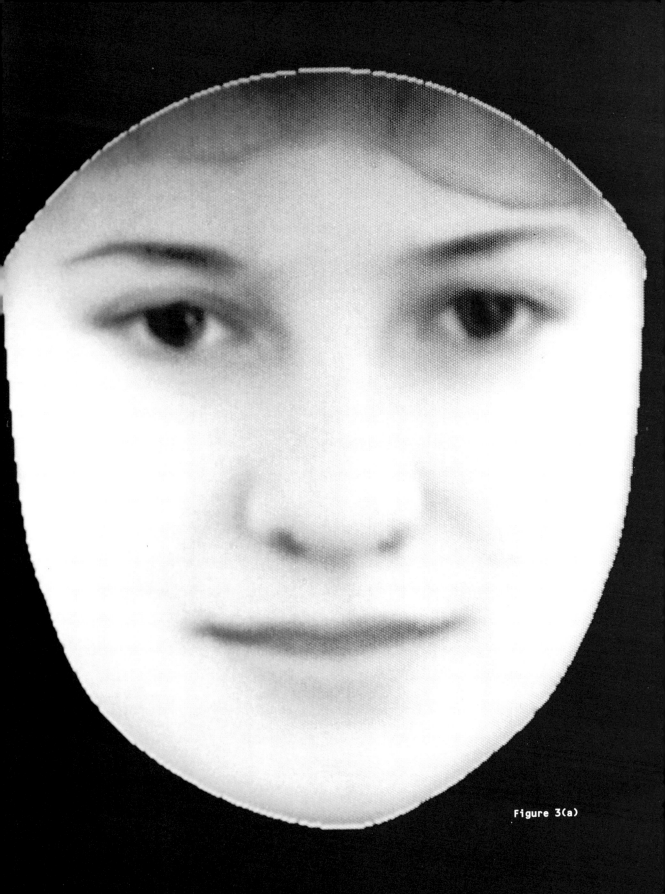

Figure 3(a)

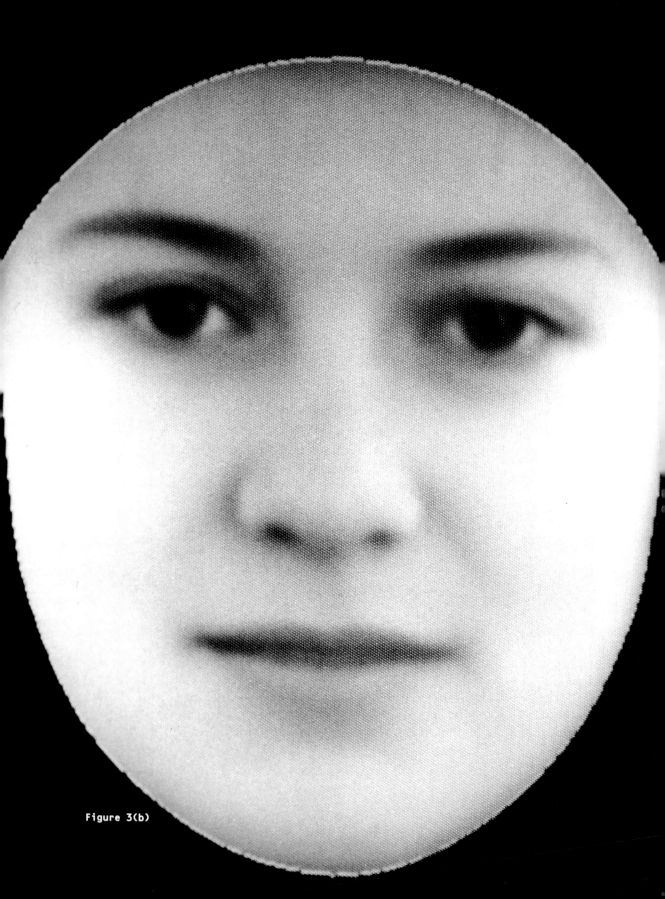

Figure 3(b)

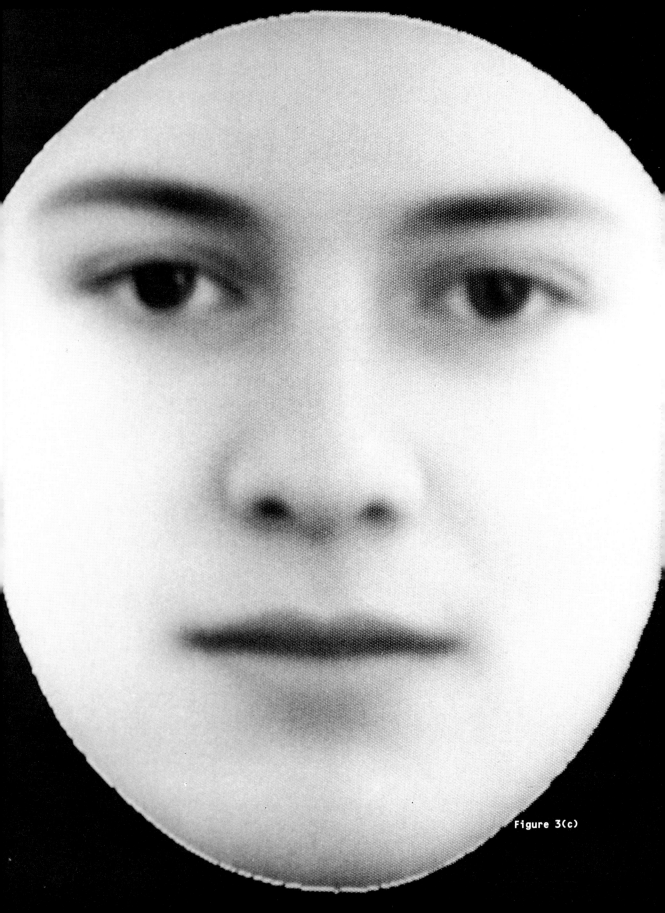

Figure 3(c)

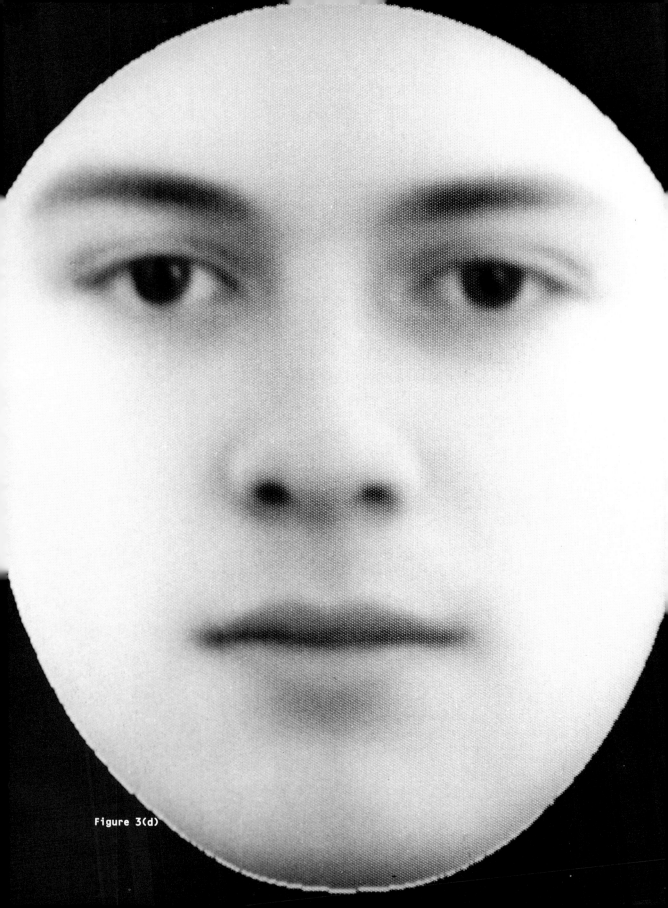

Figure 3(d)

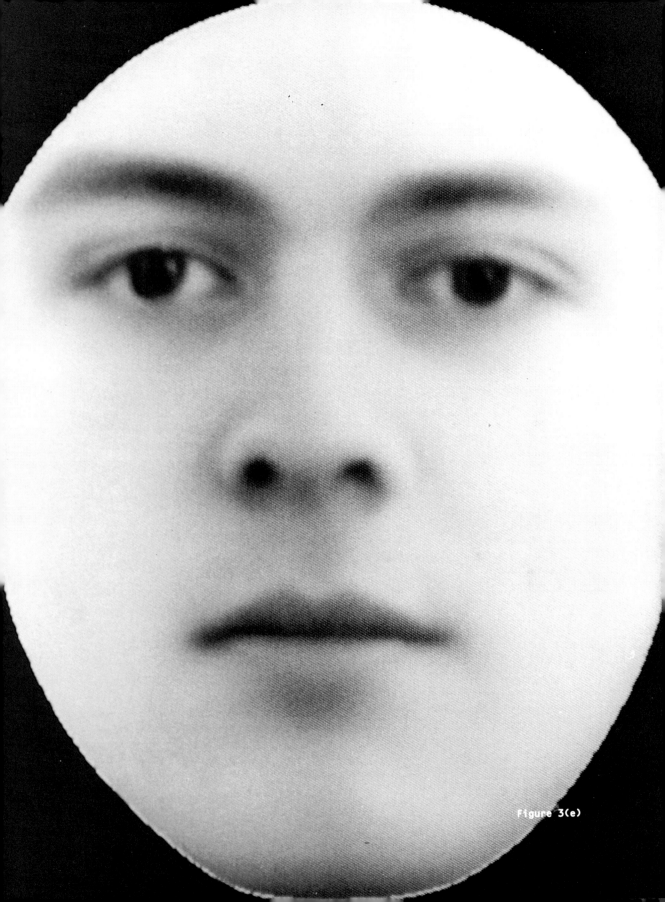

figure 3(e)

wisdom and a true unerring perception'.[6]

The differences apparent in figure 3 are average tendencies. We may be unaware of some of the differences because of variations between individuals of the same sex. Nonetheless our perceptual system may extract general tendencies in bodily and facial appearance even when we cannot give an explicit verbal description of all the differences between males and females.

There are two factors which may contribute to the attractiveness of the composites. The first is the smoothness of skin-tones. The blending process averages out freckles or pimples and any skin irregularities present in the original sample of faces, creating an even, almost bland composite visage. This can be considered analogous to the effect of applying foundation cream and powder in cosmetics, or to the effect of soft focus in photography.

The second potential influence is the shape of the face and its features. An average face will, by definition, have an overall average shape. It may be, as several authors have speculated, that beauty is defined by the extent that facial shape approaches average proportions. In the words of Langlois and Roggman 'attractive faces are only average'.

The techniques to produce composites to date have confounded the effects of face shape and skin texture. We therefore modified the graphic manipulations of face images to assess the potential contributions of these two factors on perceived attractiveness.

With a sample of sixteen male and sixteen female faces we first made composite male and composite female faces. As expected, these composites with blended skin textures and average shape were considered more attractive than the entire set of original faces.

To determine the effect of skin texture alone we distorted the shape of the male and female blended composites back into the shape of the original faces. This process reconstructed the appearance of each individual's face but with the smooth skin textures characteristic of the blended composite. There was a marked increase in attractiveness for the faces reconstructed in this way compared to the original, real faces. This confirms that smooth skin texture and colouration has a critical role in perceived beauty.

To assess the role of face shape we distorted the shape of each of the original faces to that of the composite of the same sex. This transform maintained the skin pigmentation (including any freckles or blemishes) exactly as it was in the original image (figures 4a, 4b). This shape modification was sufficient to produce a small, but consistent, increase of attractiveness ratings of the original faces. The importance of the face configuration was also apparent in the blended composites where the average shape was perceived as more attractive than the reconstructed images with the shape of the original faces.

To summarize, both the smoothness of skin

Figure 4: Manipulating facial attractiveness
Faces were masked to prevent hair and ears influencing judgments of facial beauty. Images from the left show a young female undergoing computer 'beauty treatment' (a) original face; (b) original face distorted into the shape of an age-matched prototype; (c) the blended or composite female prototype; and (d) the smooth skin textures of the blended prototype distorted into the shape of the original face. The order of perceived attractiveness was (c) most, (d), (b), (a) least. Changing the shape of a face alone is sufficient to enhance the attractiveness of most individuals. Modifications to skin texture are more effective still.

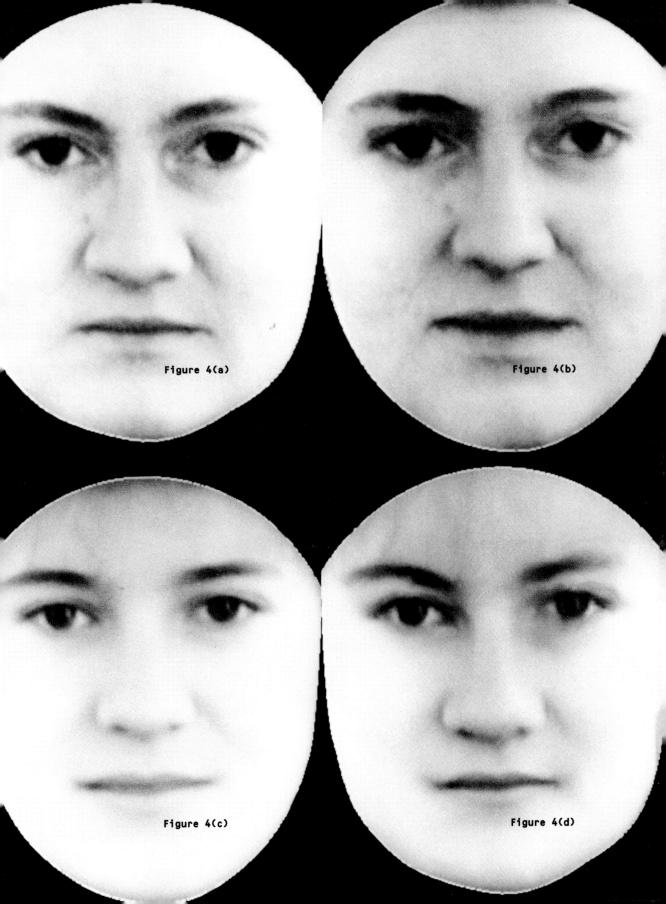

Figure 4(a)

Figure 4(b)

Figure 4(c)

Figure 4(d)

texture and the tendency of face shape towards the population average have important roles in the perception of facial attractiveness. For the male and female faces studied, skin texture and pigmentation had the largest single effect on attractiveness. Manipulating either skin texture or face shape alone produces small, but measurable, effects on attractiveness. Applying both together has dramatic effects.

Identity crises

Merging digitally stored images is not a new idea. It is a trivial matter to blend one image frame into another by means of interpolating between the intensity values at corresponding pixels in the two images. Computers are ideally suited to this kind of numerical work. They are used to produce the familiar *slow dissolves* of television, where one scene fades out and another scene simultaneously emerges. The dissolve can be applied to two images of faces. Transforming face (a) into face (b) simply by dissolving one image into another creates the problems described above whenever the features are not aligned. The result of poor alignment is equivalent to double exposure in photographic terms, so that the composite may end up with two mouths, etc.

Accurate transformation between individuals' faces must control two parameters. These are the differences in facial configuration and the differences in skin and hair colouration. One face can be merged into a second using the methods for obtaining face prototypes described above. This improved merging is illustrated in figure 5, which shows a gradual transformation between Margaret Thatcher and John Major. The shape of the original pair of face images is first modified so that the configuration of one individual's face changes in gradual steps to the configuration of the second individual, and vice versa. Pairs of images of the two faces at the same intermediate stage of configuration change are then blended together.

Blending is weighted in accordance with the stage of configuration change. Thus halfway in the dissolve, the images of Major and Thatcher have first been distorted to an intermediate shape (halfway between the two original faces) and then the two images have been blended with an equal weighting so that the pixel intensities from the two individuals contribute evenly. Similarly, to create the image that was 75 per cent Thatcher and 25 per cent Major, the images were first distorted to the appropriate shape (75 per cent of Thatcher's configuration, 25 per cent of Major's configuration) then the pixel intensities were blended in appropriate proportion (75 per cent of Thatcher's image, 25 per cent of Major's image).

1. F. Galton, Composite portraits, 'Journal of the Anthropological Institute of Great Britain and Ireland', 8 1878 pp132-42

2. F. Galton, *Enquires into Human Faculty and its Development*, London, J.M. Dent & Co. 1883

3. J.H. Langlois and L.A. Roggman, 'Attractive Faces are only Average', *Psychological Science*, 1 1990 pp115-21

4. See P.J. Benson and D.I. Perrett, 'Changing Faces' *Guardian*, 21 November 1990 p19; 'Perception and Recognition of Photographic Quality Facial Caricatures: Implications for the Recognition of Natural Images', *European Journal of Cognitive Psychology*, 3(1) 1991 pp105-35; 'Synthesising Continuous-tone Caricatures', *Image and Vision Computing*, 1991; Benson, Perrett and D.N. Davis, 'Towards a Qualitative Understanding of Facial Caricatures', in V. Bruce and A.M. Burton (eds), *Processing Images of Faces*, Norwood, New Jersey, Ablex 1991

5. D.H. Enlow, *Handbook of Facial Growth*, Philadelphia, W.H. Saunders 1982

6. J.C. Lavater, *Essays on Physiognomy*, translated by T. Holcroft, London, Ward Lock and Co. 1780

Figure 5: The changing face of Britain's Premier
The images show Margaret Thatcher turning into John Major, marking his succession as Conservative Party Leader. From the left (a) 100 per cent Thatcher; (b) 75 per cent Thatcher and 25 per cent Major; (c) 50-50; (d) 25 per cent Thatcher and 75 per cent Major; and (e) 100 per cent Major.

Figure 5(a)

Figure 5(b)

Figure 5(c)

Figure 5(d)

Figure 5(e)

Kevin Robins

the

visual technologies and

This 'into' is
the key to everything.

Jean Baudrillard

Kevin Robins works at the
Centre for Urban and
Regional Development
Studies, Newcastle, where is
he doing work on the
restructuring of the
broadcasting industry. He is
co-author (with Frank
Webster) of *The Technical Fix*
(Macmillan) and co-editor
(with Les Levidow) of *Cyborg
Worlds: The Military
Information Society* (Free
Association Books).

It's the end of
chemical photography.

David Hockney

into image
vision cultures

David Hockney says:

We had this belief in photography, but that is about to disappear because of the computer. It can re-create something that looks like the photographs we've known. But it's unreal. What's that going to do to all photographs? Eh? It's going to make people say: that's just another invention. And I can see there's a side of it that's disturbing for us all. It's like the ground being pulled from underneath us.[1]

For one-hundred-and-fifty years chemical photography held a special position as a representation of reality; but now, it would seem, that standing is being called into question. New vision technologies have made it possible to expand the range of photographic seeing – 'beyond vision' – through the remote sensing of micro-wave, infra-red, ultra-violet and short-wave radar imagery. As John Darius suggests, 'the result in all cases is an image; at what point it ceases to be a photograph is a matter of semantics.'[2]

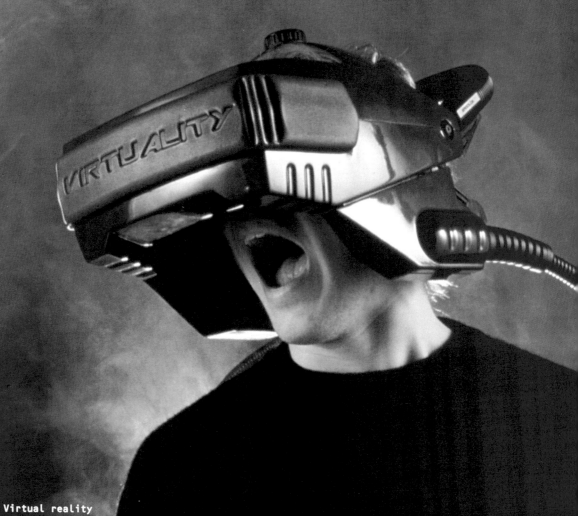

Virtual reality
The Virtuality System by W. Industries Ltd

If there have been notable developments in the ways of seeing, there has also been a significant breakthrough in the recording and handling of images. New image technologies, based on digital electronics, have also challenged what we mean by photography. We can say that these new vision and image technologies are post-photographic. 'The computer's done this', as Hockney says.

We are seeing the convergence of still and moving images, and with it the emergence of a generalized image technology and culture. But what has made this possible is the more fundamental convergence of image and computer technologies. Images have become subsumed within an overarching information system. To talk of images now is to talk of computers. The image-information product, in the form of digital electronic signals, is then opened up to almost unlimited possibilities of processing, manipulation, storage and transmission. And once it becomes possible to record photographs and other visual images in the form of digital information, then it also becomes feasible to reverse this process and to generate information that will produce or simulate an image *ex nihilo*, as it were. This capacity to generate a 'realistic' image on the basis of mathematical applications that model reality is the most dramatic and significant development of this new post-photography. It has become the major focus for research and development. Thus at Massachusetts Institute of Technology's (MIT's) Media Lab, more sophisticated and futuristic developments of these technological principles are centred around the creation of computer-generated holograms, and even the virtual reality of an artificial computer universe. Here, we are told, the convergence of artificial intelligence, robotics and animation technologies is about 'reinventing the world from scratch', about moving on from the old realities to a brave, new, virtual world.[3]

The capacities of these new-image technologies are certainly impressive. But just *how* significant are these developments? And, indeed, *what* is the real nature of their significance? These are the questions that I want to pursue through the course of this essay. To do so, it is necessary to move beyond the technological, and often technocratic framework within which most discussions of post-photography have so far been conducted. We should be suspicious about talk of a technological revolution, or of an emergent information age. The question of technology, as I shall argue, is not at all a technological question. What seem to me of the utmost importance are the social and cultural forces that are stimulating the development of automatic and cybernetic vision. The new image technologies have been shaped by, and are informed by, particular values of western culture; they have been shaped by a logic of rationality and control; and they are informed by a culture that has been both militaristic and imperialistic in its ambitions. In this light, we may be less impressed about the techno-revolutionary claims being made about the transition from chemical photography to electronic imaging. In refusing to fetishize the technologies, we are less likely to experience the disturbing sense of future shock that David Hockney invokes, and more able to

1. William Leith, 'At home with Mr Hockney', *Independent on Sunday*, 21 October 1990 p37

2. John Darius, *Beyond Vision*, Oxford, Oxford University Press 1984 p17

3. Stewart Brand, *The Media Lab: Inventing the Future at MIT*, New York, Viking 1987 pp113-16

recognize and acknowledge the continuities and transformations of particular dynamics in western culture.

Beyond the reality principle?

The hermit turns his back on the world, and will have no truck with it. But one can do more than that; one can try to re-create the world, to build up in its stead another world in which its most unbearable features are eliminated and replaced by others that are in conformity with one's own wishes.

Sigmund Freud, *Civilization and its Discontents*

I want to begin by looking at what I would call the techno-fetishistic approach to new image technologies. What is immediately striking about it is the feeling of euphoria and the sense of omnipotence that these new technologies can arouse. There is an exultant sense of unbounded possibilities being opened up:

Photographers will be freed from our perpetual constraint, that of having, by definition, to record the reality of things, that which is really occurring…Freed at last from being mere recorders of reality, our creativity will be given free rein.[4]

The introduction to a recent conference programme is more flamboyant still. Here we are told that 'the increasing progress in digital images and the perfecting of display and multisensorial interaction systems, henceforth, make it possible to immerse oneself physically in totally constructed symbolic, visual, sonorous and tactile spaces.' The new computer images, it continues,

these beings which achieve such a singular hybridization of the intelligible and the visible, give us access to a new world, a tabula rasa, where the most gestural metaphors and the most formal logic, the most spontaneous movements and the most tortuous models, are inextricably intertwined.

How are we to answer the Cassandras of derealization? We have long dwelt in the land of images, and we know full well that illusion ceases where enjoyment begins.

We are offered experiences that shatter all certitude; experiences that 'ostensibly pose the problem of the nature of reality, and that of our relationship to its representations.'[5] Suddenly released from the mundane reality we have always had to come to terms with, we have the freedom now to enter new worlds, 'the worlds we wish to know'. For those who 'conspire in electronic visualization', there can no longer be any meaningful return to some 'authentic reality'.

According to Gene Youngblood:

The fear of 'losing touch with reality', of living in an artificial domain that is somehow 'unnatural', is for us simply not an issue, and we have long since elected to live accordingly. What matters is the technical ability to generate simulations and the political power to control the context of their presentation. Moralistic critics of the simulacrum accuse us of living in a dream world. We respond with Montaigne that to abandon life for a dream is to price it exactly at its worth. And anyway, when life is a dream there's no need for sleeping.[6]

One is forcibly struck by the idealization of the new technologies and by the quasi-mystical feelings that they arouse. These are powerful expressions of fantasy and desire. What is significant, however, is that they are articulated through the discourse of science and rationality. The discussion of image futures quickly translates into one about computers and their logic. The computer is the symbol of omnipotent reason. For Youngblood, the computer is the ultimate metamedium, the medium that can simulate, and thereby contain or become, all other media (and image generation is just one part of its multimedia domain). Indeed, it may well be 'the most profound development in the history of symbolic discourse'; it is possible 'to view the entire career not only of the visual arts but of human communication in general as leading to this Promethean instrument of representation', this 'universal machine.'[7] The universal machine is (western) scientific rationality brought to its culmination. Finally, reason has been harnessed to overcome worldly limitations and to make all things possible.

In this ideal domain, the mundane laws of reality are suspended and transcended, and all phenomena exist virtually, that is to say they exist in effect, 'for all practical purposes', though not in actual fact. Thus 'if photography is making marks with light, then computer imaging is a kind of photography, but one in which the "camera" is only a point in virtual space and the "lens" is not a physical object but a mathematical algorithm that describes the geometry of the image it creates.'[8] Computer images may 'exist informally in an intuitive space with other visual objects, but they derive from a formal space in the computer's memory.'[9] What is created, it is argued, is a new kind of data space – a virtual logical space – and the image exists essentially in this space 'as a kind of Platonic ideal':

We gaze in fascination upon these digital simulacra: they possess an 'aura' precisely because they are simulacra, vivid chimera of a new kind of eidetic vision. They refer to nothing outside themselves except the pure, 'ideal' laws of nature they embody. They have that 'quality of distance' no matter how many degrees of manipulative freedom we have over them, because they exist in the dematerialized territory of virtual space.[10]

Through the creation of this simulated and surrogate reality, it is suggested, our sense of, and allegiance to older realities may be fundamentally transformed.

4. Mike Laye, 'From today, is photography dead?' *Image*, no172, January1990 pp11-12

5. Philippe Quéau, *Programme for Imagina 91*, Tenth Monte Carlo Forum on New Images, 30 January – 1 February 1991

6. Gene Youngblood, 'The new renaissance: art, science and the universal machine', in Richard L. Loveless (ed.), *The Computer Revolution and the Arts*, Tampa, University of South Florida Press 1989 p15

7. Ibid. p16

8. Ibid. p17

9. Richard Wright, 'Computer graphics as allegorical knowledge: electronic imagery in the sciences', in *Digital Image – Digital Cinema: Siggraph '90 Art Show Catalog*, Leonardo, Supplemental Issue 1990 p69

10. Youngblood, op.cit. p15

At one level, it is a discourse on pure reason and on the purity of reason. But it is more than this. What is desired in this worldview is the revitalization and re-enrichment of reason. Contemporary society is experienced in terms of a crisis of imagination and creativity. For Youngblood, it is about trying to change impoverished attitudes and values, about 'trying to rethink ourselves, realign ourselves, trying to live up to our troubled and inarticulate sense of new realities.' This process of resocialization, he suggests:

> presupposes an ability to hold continuously before ourselves alternative models of possible realities, 'consciousness raising' but the redefinition and reconstruction of consciousness. It is comparable to religious conversion, psychotherapy, or other life-changing experiences in which an individual literally 'switches worlds' through a radical transformation of subjective identity. This requires continuous access to alternative social worlds…that serve as laboratories of transformation. Only in such autonomous 'reality-communities' could we surround ourselves with counter-definitions of reality and learn how to desire another way of life.[11]

The new technologies are seized upon as possible means to construct an alternative culture, and maybe even a new age. In this age, this new renaissance, it is projected, reason may once again be united with imagination, and science and art may be harmoniously re-united.

Another way of life sounds desirable, but it is difficult to imagine that it can be served up courtesy of these new image-information technologies. This idea of new 'reality communities' is more a fantasy projection than a serious proposal for social change. Nonetheless, if we cannot believe in the radical programme of 'switching worlds', we can agree that the new technologies do raise important philosophical questions about actually existing reality. One agenda concerns how we know and apprehend the world – questions of epistemology, representation and truth. It is this question of veracity that David Hockney finds disturbing about post-photography. Digital technologies put into question the nature and function of the photograph/image as representation. The essence of digital information is that it is inherently malleable and plastic: 'The unique computer tools available to the artist, such as those of image processing, visualization, simulation and network communication are tools for changing, moving and transforming, not for fixing, digital information.'[12] Through techniques of electronic montage and manipulation, what we once trusted as 'pictures of reality' can now be seamlessly, and undetectably, edited and altered.[13] The status of the photographic document as evidence is thereby called into doubt.

Whole new vistas are then opened up for the manufacture of fakes, fabrications and misinformation. The relation between the photographic image and the 'real world' is subverted, 'leaving the entire problematic concept of representation pulverized…and destabilizing the bond the image has with time, memory or history.' What this represents can, indeed, be justifiably described as 'a funda-

mental transformation in the epistemological structure of our visual culture.'[14] This is all the more so when the images are computer-generated rather than simply computer-manipulated. If the computer image appears 'realistic' – if it 'positively enshrines photographic realism as the standard, unquestioned model of vision' – it is the case that the referent is not, in fact, 'in the real world', but is itself an image, a mathematical-informational representation.[15] Reality is no longer represented, but is simultaneously modelled and mimicked. Through this process of simulation, the whole question of accuracy and of authenticity becomes not simply problematical, but apparently, at least, anachronistic and redundant.

This brings us to a second philosophical agenda occasioned by the proliferation of these imaging technologies. The crisis of the relation between image and reality raises questions concerning the status of the image realm. The techno-futurists emphasize particularly the ontological question of decidability between the real and the unreal. As Gene Youngblood puts it:

a digitally processed photograph, for example, can no longer be regarded as evidence of anything external to itself. Digital scene simulation has deprived photography of its representational authority just as photography disqualified painting in the nineteenth century; but this time the question of representation has been transcended altogether.[16]

The dislocation of image from referent reinforces its perception as a domain in its own right. Through the problematization of any indexical or referential relation to reality, the image-space, or data-space, assumes for itself an increasing autonomy. In the factitious space, the formal and logical space, of the computer, it has become possible to simulate a surrogate reality, a kind of alter-reality which is difficult to differentiate from our conventional reality and which, it is claimed, even threatens to eclipse it. It might seem as if what we have got used to calling the real world had been both displaced and replicated by a ghostly double. But maybe it was actually that the old reality was only ever an imperfect precursor or prefiguration of the emergent virtual world anyway. Maybe that old reality was only a kind of pre-technological simulation:

We habitually think of the world we see as 'out there', but what we are seeing is really a mental model, a perceptual simulation that exists only in our brains. That simulation capability is where human minds and digital computers share a potential for synergy. Give the hyper-realistic simulator in our heads a handle on computerized hyper-realistic simulators, and something very big is bound to happen.[17]

The belief is that when we finally come to be immersed in this 'cyberspace' we shall be able to realize our true and full potential.

There is a new frontier, it would seem, and there are those who see themselves as the new settlers. The new image and simulation technologies are supposed to

11. Ibid. pp9-10

12. Roger F. Molina, 'Digital image-digital cinema: the work of art in the age of post-mechanical reproduction', in *Digital Image-Digital Cinema: Siggraph '90 Art Show Catalog*, Leonardo, Supplemental Issue 1990 p3

13. For discussion, see Fred Ritchin, *In Our Own Image: The Coming Revolution in Photography*, New York, Aperture 1990; Fred Ritchin, 'Photojournalism in the age of computers', in Carol Squiers (ed.), The Critical Image, Seattle, Bay Press, 1990; Karin Becker, 'To control our image: photojournalists meeting new technology', in this volume pp17-31

14. Timothy Druckery, 'L'amour faux', Perspektief, no37 December 1989-January 1990 pp37, 41

15. Don Slater, 'Image worlds', *Ten-8*, no22 1986 p35

16. Youngblood, op.cit. pp13-14

17. Howard Rheingold, 'What's the big deal about cyberspace?', in Brenda Laurel (ed.), *The Art of Human-Computer Interface Design*, Reading, Mass, Addison-Wesley, 1990 p450

provide the doorway to new and other worlds: 'when you're interacting with a computer, you are not conversing with another person. You are exploring another world.'[18] This new world is an ideal world, a world beyond gravity and friction. In this world, human consciousness and intelligence are amplified. Cyberspace is imagined as 'an amusement park where anything that can be imagined and programmed can be experienced. The richness of the experiences that will be available in cyberspace can barely be imagined today.'[19] This, at its most hyperbolic, is 'where the interpersonal, interactive consciousness of the world mind is emerging…where minds of tomorrow will mirror themselves, meet each other, enter the universe of information and knowledge.'[20] Metaphors turn mystical.

This is what they call 'imagining the future'. Computer images mark the shift to a new visual paradigm, to a new age when we shall see things differently:

Visually-oriented computer interfaces, film, photography, and before them, painting and drawing, all changed the way people see the world. People ran screaming out of movie houses at the sight of the first extreme close-ups of giant faces on the screen. The Renaissance was influenced as much by the introduction of perspective as by the rediscovery of Greek philosophy. It is part of a cultural evolutionary process: every time a widely seen visual paradigm breaks into a new dimension, reality shifts a little. In the case of the cyberspace transformation (because of the nature of the digital computer), it looks like reality is going to change a lot.[21]

Of course, it is true that images have always served to disrupt our taken-for-granted and habitual sense of reality. And photography has had disturbing implications for what we have understood to be the real world, exposing us to the unreal dimensions of that reality and even encouraging us to believe that the captured image is somehow more real. But now we are asked to seriously consider the idea that images can, literally, displace and replace reality. We are asked to believe that we could inhabit this other-world of simulation.

What does it actually mean, though, to 'dwell in the land of images' and to 'abandon life for a dream'? If we aren't moved by this scenario, we might be tempted just to dismiss it as vacuous fantasy. Perhaps, however, we should take it seriously, insofar as it is a symptomatic reflection of the kind of world we are living in. We should take seriously the cultural, psychic, and also political, roots that nourish this desire and this vision. And we should consider it, not only in terms of its positive aspirations (to imagine and visualize other ways of being in the world), but also in terms of the negative motivations (discontentment with the perceived inadequacy of the existing world). In Freud's terms, this 'reality shift' might be seen in terms of strategies aimed at the 'avoidance of unpleasure'; it is about coping with frustration from the external world. To this end the new technologies can be mobilized, either to 'loosen the connection' with reality, or alternatively, to 'remold' it.[22] Hasn't this instinctual need always been a driving

force in technological innovation? We can follow Susan Sontag's insight that photography is both 'a defence against anxiety and a tool of power.' In the light of a felt sense of insecurity, images are mobilized to achieve symbolic or imaginary possession over space.[23] They are about containment and control.

Virtual reality: into the microworld

Everywhere the transparency of interfaces ends in internal refraction.

Jean Baudrillard

The idea that we are living in a simulation culture has by now become almost a cliché. We are already more than familiar with Jean Baudrillard's descriptions of simulacra and simulations, of a de-territorialized hyper-reality, of images or models of a real without origin or reality. The idea has slipped almost effortlessly into the discourse of postmodernism, and we have actually come to feel rather comfortable with our new condition of derealization. There is, of course, an important truth in this analysis. We do live in a world where images proliferate independently from meaning and referents in the real world. Our modern existence is increasingly one of interaction and negotiation with images and simulations which no longer serve to mediate reality. As Scott Lash has argued, postmodernism is centred around the problematization of reality.[24] We now articulate our identity through coming to terms with the image rather than the reality. The system of images, apparently self-contained and auto-referential, comes to assume its own autonomy and authority.

But if there is a kind of truth in this analysis, what is its significance? What kind of truth is it? The spectacular culmination of this tendency to replace the world around us with an alternative space of images and simulations is the creation of so-called Virtual Reality environments. In this new computer image technology, we can identify some fundamental aspects of the social and psychic investment in simulation culture. The terms 'virtual' or 'artificial' reality 'refer to the computer generation of realistic three-dimensional visual worlds in which an appropriately equipped human operator can explore and interact with graphical (virtual) objects in much the same way as one might in the real world.'[25] Through the use of a range of input devices (a helmet-mounted display panel, data-gloves, data-suit), it becomes possible to generate the simulation of a three-dimensional world in which the operator is an active and involved participant. It is as if he or she were inside the image, immersed in the new symbolic environment, with the 'means of interacting with that virtual world – of literally reaching in and touching the virtual objects, picking them up, interacting with

18. John Walker, 'Through the looking glass', in Brenda Laurel (ed.), *The Art of Human-Computer Interface Design*, Reading, Mass., Addison-Wesley, 1990 p443

19. Ibid. pp446-7

20. Timothy Leary, 'The interpersonal, interactive, interdimensional interface', in Brenda Laurel (ed.) *The Art of Human-Computer Interface Design*, Reading, Mass., Addison-Wesley, 1990 p232

21. Rheingold, op.cit. p452

22. Sigmund Freud, *Civilization and its Discontents*, London, Hogarth Press, revised edition, 1963 pp14-18

23. Susan Sontag, *On Photography*, Harmondsworth, Penguin, 1979 pp8-9

24. Scott Lash, *Sociology of Postmodernism*, London, Routledge, 1990 pp12-14

25. Robert J. Stone, 'Virtual reality in telerobotics', in *Computer Graphics*, Proceedings of the Conference held in London, November 1990, Pinner, Blenheim Online, 1990 p32

virtual control panels, etc.'[26] The virtual environment is one in which cybernetic feedback and control systems mimic the interaction with real objects, such that the environment appears to be real and can be used as if it were real.

Virtual reality technologies have emerged out of space and military programmes (an absolutely fundamental point, to which I shall return). The original developments involved techniques of telepresence and telerobotics, with the objective of controlling, or potentially controlling, operations at distant or hazardous sites (space and deep-sea exploration; battlefield situations; nuclear and toxic environments). If the means was to create the illusion of presence at such a site, the clear objective was to manage or transform real situations. In the projected US space station, for example, it is envisaged that the astronauts will be able to control a robot outside the station with 'the robot's camera system providing stereo images to the operator's head-mounted display while precisely miming his head movements, and the robot's dexterous end-effectors would be controlled by dataglove gestures.'[27]

If the initial aim was to control reality through illusion, it became apparent that it was also possible to use the illusion in its own right. Such 'free-standing' applications could be used for a range of practical and commercial purposes: aircraft cockpit simulation to analyze the decision-making procedures of pilots under controlled conditions; architectural simulation to model buildings cheaply in virtual space before physical construction; surgical simulations for training medical students. It is this exploitation of 'pure' simulation that characterizes virtual reality systems proper.

And it is this dimension that has become the basis of subsequent educational and entertainment and applications. There are already numerous companies in Britain (W. Industries, Division), the United States (VPL, Autodesk) and Japan (Sharp, Mitsubishi, Sanyo) vying for what seems to be a burgeoning new market. It has already been announced that the world's first virtual reality theme park will open in the Japanese city of Osaka in 1995. Already, and predictably – the key index, perhaps, of popular (read male) acceptance – the idea of cybersex and virtual pornography is on the cultural agenda. As yet, we should be clear, such virtual reality applications are much less than perfect, and many technical problems still have to be resolved.[28] Nonetheless, there is a strong and growing belief in the potential of 'cyberspace entertainment'. Already it has become a matter of interest and speculation in the non-specialist press.[29] What is so attractive about (the idea of) artificial worlds? What is it about the current dissatisfaction with 'real' reality that makes liberation through simulation – 'switching worlds' – seem so desirable?

As the idea of virtual reality entertainment comes to public awareness, what is clear is that the imaginative mould has already been set: there is already a wholehearted agreement about its 'revolutionary' significance and a deafening consensus about its 'challenging' potential. The discourse turns out to be

extremely predictable, and invariably quite pedestrian. The visionary cyberspace rhetoric embodies the all too familiar *imaginaire* of high-tech futurism. There is a clichéd feel. In all the material I have read on virtual reality the same reference points are invoked over and over again. There is the almost obligatory mention of MIT's Media Lab, particularly as it has been mythologized by Stewart Brand. There are invariably quotations from the post-LSD Timothy Leary. Then we generally have a scattering of aphorisms from Jaron Lanier, always described as 'the inventor of the EyePhone and DataGlove', who has become the techno-spiritual guru of the new movement: 'Information is alienated experience'; 'the computer is the map that you can inhabit'; '...a sharing of many imaginations'; '...the first medium to come along that doesn't narrow the human spirit' (and there's plenty more of this unsparkling visionary wisdom). And, of course, there is the almost religious reference to cyberpunk fiction writers like Bruce Sterling and, particularly, William Gibson. Gibson is the seer of seers. It was he who invented the very idea of cyberspace ('A consensual hallucination...A graphic representation of data abstracted from the banks of every computer in the human system. Unthinkable complexity...clusters and constellations of data',[30] and so on). Cyborg movies like *Tron* and *Blade Runner* and *Robocop* are also key points of reference. And, on top of all this science-fiction stuff, there is finally the inevitable reference to Baudrillard's writings on simulation and hyper-reality.

This, when it's all shaken together, becomes the founding dogma through which all mortal beings might learn to find their way to the other world. These are the canonical texts, and seldom are they departed from. What it represents is the convergence of cybernetics, science fiction, postmodernism and New Age philosophy into a synthetic new Utopianism. This convergence reflects the belief that we are at the threshold of a fundamental cultural and psychic transformation. We are told that virtual reality 'can be explored as a new mode, an instrument which questions how we have defined reality, where we draw lines, if the lines are necessary.' Virtual reality, it is said, opens up a 'universe of questions' and 'challenges us to the roots of how we define reality, presence, point of view, even identity.'[31] But who is being challenged? The new reality seems strangely more reassuring than disturbing; it can be readily and easily accommodated within prevailing cultural and philosophical agendas. It's a kind of fantasy-game icing on an old technological cake:

There seems to be a flavour of longing here which I associate with the desire to converse with aliens or dolphins or the discarnate. For a long time now technology has been about the business of making the metaphorical literal. Let's reverse the process and start to reinfect ordinary reality with luminous magic. Or maybe this is just another expression of what may be the third oldest human urge, the desire to have visions.[32]

It's a very mechanical desire to have visions. This is a discourse that is at once

26. Scott S. Fisher, 'Virtual interface environments', in Brenda Laurel (ed.), *The Art of Human-Computer Interface Design*, Reading, Mass., Addison-Wesley, 1990 p430

27. Ibid. p453

28. See Gregory MacNichol, 'What's wrong with reality?', *Computer Graphics World*, November 1990

29. See, for example, David Gale, 'At the other end of nature', *Guardian*, 13 April 1990; Sam Kiley, 'Active video: it's out of this world', *Sunday Times*, 17 June 1990; Steve Connor and Robin Baker, 'A step through the looking-glass', *Independent on Sunday*, 4 November, 1990; Brian Walker, '3D lease of life for the arcades and theme parks', *Guardian*, 22 November 1990; Ian Grant, 'Reality – but not as we know it', *Guardian*, 27 December 1990

30. William Gibson, *Neuromancer*, London, Grafton Books, 1986 p67

31. Regina Cornwell, 'Where is the window? virtual reality technologies now', *Artscribe*, January-February 1991 p55

32. John Perry Barlow, 'Being in nothingness', *Mondo 2000*, no2 1990 p41

romantic and technocratic.

Theodore Roszak describes the emergence, in the 1960s and 1970s, of a counter-cultural movement in the United States of what he calls 'reversionary technophiles'. These 'guerrilla hackers' were entirely committed to computer electronics and global telecommunications, but sought to contain the new technology within an organic and communitarian context; what they sought was 'a synthesis of rustic savvy and advanced technology'.[33] It is difficult not to see the virtual reality gurus as their latter-day successors. There is a direct lineage from Timothy Leary then to Timothy Leary now, and from Timothy Leary then to Jaron Lanier now. If the Californian counter-culture has been a crucial institutional base for this kind of techno-romanticism, there have also been variations and transformations in other social and geographical contexts. In Britain it has been New Age philosophy that has sustained the same, or similar, cultural objectives. Here we can see the interest in virtual reality developing in the context of a broader holistic meta-philosophy *(avant-garde* arts, chaos theory, 'soft' business philosophies, artificial intelligence and mysticism, ecology).

It is on the basis of these cultural-institutional interest groups that the discourse has subsequently diffused into mainstream and popular expectations about the promise of virtual reality environments. It is not difficult to see why it is so appealing. If, in the past, technologies have created a sense of alienation, what these new technologies promise is nothing less than the 're-enchantment' of our mundane existence. 'You can go to distant planets and sit on the rings of Saturn', says Jaron Lanier. 'Enter the prehistoric world of the Tyrannosaurus or fly across cities.'[34] The discourse appeals because it is all about imagination and creativity. 'I know', writes another cyber-pioneer, 'that I have become a traveller in a realm that will be ultimately bounded only by the human imagination, a world without any of the usual limits of geography, growth, carrying capacity, density or ownership.'[35] And all this is so very acceptable because it never once challenges conventional (that is, romantic) beliefs about the relationship between imagination and technology, art and science. The idea of such creative empowerment has always been central to the dominant technological *imaginaire*. But if the new technologies of the past always let us down, this time, finally, through this revolutionary new technology, there is a conviction that the ambition will be realized. In the world of virtual reality, the ideal can at last be made real. In this (probably adolescent male) aspiration to creative omnipotence, the promise of technological Utopia is kept alive and kicking.

To understand this great faith in virtual reality technologies, we need to understand what is so engaging about them, and how they implicate their believer-users. What of themselves are these users investing in the virtual reality? What is that particular combination of rational and pre-rational pleasures that the technologies speak to? Discussion of these technologies has tended to place greatest emphasis on the seductive realism of the virtual reality image. So realistic

is it that it seems to be an alternative – and better – world of its own. But if the fascination of the reality-effect is important, perhaps more so is the question of *interactivity*, and it is through this dimension, I think, that we can gain a better insight into the involvement and both conscious and unconscious energies in the new technologies. Virtual reality environments, we are told, depend on the 'ability to interact with an alter ego':

Interfaces form bridges between the real and the virtual and back again. We cross them to inhabit a strange place that is both concrete and abstract. A human hand grasping a real sensor holds, at the same time, a virtual paint brush or the controls of a virtual space vehicle.[36]

Interactivity is fundamental to simulation. What is exciting about the virtual reality experience is that it involves 'interaction not with machines but with people mediated through machines: it's interaction with intelligence, with mind.' With this high level of interactivity, 'the environment changes as a result of the user's interaction with it, so that possibilities are generated that the author didn't think of.'[37] The objective (still a long way from being realized) is to make the interface as direct and immediate as possible: 'with a little imagination, one can envision human-machine interaction beyond a keyboard and mouse to the natural and kinesthetic way we encounter the real world. Input devices for our hands, arms, head, eyes, body, and feet can sense positions, gesture, touch, movement, and balance.'[38] The challenge is to create a direct connection between the technology and the human nervous system. The dream of eliminating the interface – 'the mind-machine information barrier' – reflects the desire to create a perfect symbiosis between the technology and its user.

What is this concern with the continuity of our relation to the computer? What is significant about the fantasy of union? There is a radical possibility. To provoke these questions could be to undermine our belief in human distinctiveness and to challenge our commonsense assumptions about self and identity. What kind of people are we becoming? Where, now, is the line between the natural and the artificial? These are questions raised, not only by virtual reality, but by artificial intelligence and cybernetic technologies more generally. They are not new questions, but they remain important ones.[39] It is this relation between technology and identity that has been developed in popular cultural explorations of cyborg culture – the fiction of William Gibson, for example, and also films like *Robocop* and *Blade Runner*.[40]

What is significant about these kinds of cultural discourse, at their best, is that they have staged the encounter of the human and the technological in terms of radical confrontation; they have explored the risks and anxieties presented to our immediate sense of reality by new technologies. The champions of virtual reality, however, have refused this radical confrontation. Their fantasy is structured round the evacuation of the real world, as it were, and the redefinition of self

33. Theodore Roszak, *The Cult of Information*, Cambridge, Lutterworth Press, 1986 pp146-50

34. Quoted in Stoned Lewis and Karen Peet, 'It's real – virtually', *Wave*, Launch issue, Autumn 1990 p46

35. Barlow, op.cit. p36

36. Timothy Binkley, 'Digital dilemmas', in *Digital Image – Digital Cinema: Siggraph '90 Art Show Catalog, Leonardo*, Supplemental issue, 1990 p18

37. Youngblood, op.cit. p18

38. Michael Naimark, 'Realness and interactivity', in Brenda Laurel (ed.), *The Art of Human-Computer Interface Design*, Reading, Mass., Addison-Wesley 1990 p457

39. Joanna Pomian, 'À la recherche de la machine communicante', *Quaderni*, no5, Autumn 1988. For earlier discussions see J. Bronowski, *The Identity of Man*, Harmondsworth, Penguin, 1967, ch1; Bruce Mazlish, 'The fourth discontinuity', *Technology and Culture*, vol8 no1 1967

40. On Gibson, see David Thomas, 'The technophilic body: on technicity in William Gibson's cyborg culture', *New Formations*, no8, Summer 1989; Fred Pfeil, 'These disintegrations I'm looking forward to: science fiction from new wave to new age', in E. Ann Kaplan and Michael Sprinker (eds), *Cross Currents: Recent Trends in Humanities Research*, London, Verso 1990. On the films, see Fred Glass, 'The 'new bad future': *Robocop* and 1980s' sci-fi films', *Science and Culture*, no5, 1989; Giuliana Bruno, 'Ramble city: postmodernism and *Blade Runner*', *October*, no41 1987

and identity in terms of the virtual and private microworld. Theirs is a regressive strategy. The microworld is a container: in it 'reality' is made tractable and composable. The virtual world 'fosters a fetishized relationship with the simulation as a new reality all its own based on the capacity to control, within the domain of the simulation, what had once eluded control beyond it.'[41] The real world that was once beyond is now effaced: there is no longer any need to negotiate that messy and intractable reality. The user is now reconceived as an aspect of, and operates entirely in terms of, the logical universe of the simulation. That is to say, the virtual reality environment is 'user-friendly':

A 'user-friendly' machine, method, or mode of social organization is one in which the user detects no difference between the environment and his idea of it. 'User-friendly' technology thus has to do with efficiency, and pure efficiency is an isomorphic state – a system in which all parts are in such coordination as to relieve all tension.[42]

Real experience is denied; everything is simulation. Desire and lack are disavowed. The tensions and frustrations and anxieties of existence are allayed: 'The expenditure of forces is restricted to mere maintenance and control. There is novelty, but nothing – strictly speaking – that is new.'[43]

The microworld is an artificially constructed domain which is self-contained and independent of the complexities of the real world 'outside'. The concept, developed originally in the context of educational computing by Seymour Papert, is that through exploring the particular properties of a microworld, it is possible to affirm 'the power of ideas and the power of the mind', and to do so without being disturbed by 'extraneous questions'.[44] The microworld is a safe and predictable environment. Like other kinds of micro-environment (board games or card games, for example), it is structured by a set of rules, a set of assumptions and constraints; within the terms of these rules everything is possible, though nothing can be arbitrary or contingent.

In the case of the virtual microworld, however, what is significant is that the user is removed from the fullness of 'real' human existence. As with video games, the machine 'takes the player out of this world'; it encourages 'disembodied activity'.[45] It is possible to become immersed, even drowned, in the simulated reality: 'Like Narcissus and his reflection, people who work with computers can easily fall in love with the worlds they have constructed or with their performances in the worlds created for them by others.'[46] In those who have gone 'into' the image you see the solipsism of what Baudrillard calls 'narcissistic refraction'.[47]

Virtual reality is a 'mind-space'. It is projected as a domain of cognition and rationality, 'where minds of tomorrow will mirror themselves, meet each other, enter the universe of information and knowledge.'[48] In this sense, to enter the microworld is apparently to enter a world of order and reason. But it is more than this. The microworld is also responding to deeper needs and drives than

those of reason. This image space is also a container, and a scene for unconscious and pre-rational dramas: getting 'into' the image is also about acting out certain primitive desires and fantasies, or about coming to terms with fears and anxieties. Philippe Dubois has argued that two mythological figures – Narcissus and Medusa – can symbolize our psychic investment in, and our neurotic ambivalence about, the image. The one reflects our (infantile) desire to take the image for real, to embrace it, and to become submerged in and joined with it. The other stands for the anxieties we experience in the face of the images we have created, for the conflicting feelings of attraction and repulsion, desire and fear, that are aroused by their power.[49]

In the image world of virtual reality, I would argue, the same psychic dramas are at stake. Thus, in Christopher Lasch's terms, the aspiration towards perfect symbiosis with the microworld may be rooted in the Narcissistic longing for fusion. Such Narcissistic regression, he suggests, seeks freedom from 'the prison of the body'; it is driven by an infantile 'longing for the complete cessation of tension.' Narcissism is a state in which the organism forms a closed unit in relation to its surroundings. It seeks to recover the lost, infantile, paradise:

Narcissus drowns in his own reflection never understanding that it is a reflection. He mistakes his own image for someone else and seeks to embrace it without regard to his safety. The point of the story is not that Narcissus falls in love with himself, but, since he fails to recognize his own reflection, that he lacks any conception of the difference between himself and his surroundings.[50]

Narcissus was captivated by, and sought union with, his own image. The users of virtual reality may similarly be driven by the desire to embrace – to become one with, to form a closed unit with – the simulated image.

Alternatively, the possibility of virtual reality may arouse profound anxieties, and interaction with image simulations may be about the struggle to master those anxieties. Gillian Skirrow's observation about video games is insightful. She argues that there is in our culture a deep fear of technological power and, consequently, there are 'anxieties about exploitation and manipulation, about inability to separate oneself from it':

To this fear video games are in many ways the predictable male response: the video screen makes the fear visible, but obliquely, for like the Medusa, it must not be directly confronted; the visibility of the fear allows it to be expressed but remains unspoken; the quest for the performer's destiny occupies the fantasy space in which infantile battles were fought in the mother's body and won; the male references in the intertextuality of the content of the games gives the male player a sense of familiarity which helps him over the strangeness of the new technology; the domestic image and setting of the home computer constantly remind the performer of his mastery and his power to switch the machine off, even if it does beat him at his own game. And as his own game seems to be the rehearsing of his own death, to lose is only to affirm his own resurrection.[51]

41. Bill Nichols, 'The work of culture in the age of cybernetic systems', *Screen*, vol29, no1, Winter 1988 p33

42. Peter Emberley, 'Places and stories: the challenge of technology', *Social Research*, vol56, no3, Autumn 1989 p758

43. Ibid., p759

44. Seymour Papert, *Mindstorms: Children, Computers, and Powerful Ideas*, Brighton, Harvester, 1980 pp117, 119

45. Morris Berman, 'Cybernetic dream of the twenty-first century', in Richard L. Loveless (ed.), *The Computer Revolution and the Arts*, Tampa, University of South Florida Press, 1989 p84 cf. 'VR [virtual reality] could be viewed as one step in the evolution toward the withering away of the body', Cornwell, op.cit., p54

46. Sherry Turkle, *The Second Self: Computers and the Human Spirit*, London, Granada, 1984 pp77-8

47. Jean Baudrillard, *America*, London, Verso, 1988 p34

48. Leary, op.cit., p232

49. Philippe Dubois, *L'Acte Photographique*, Brussels, Éditions Labor, 1983 pp134-48

50. Christopher Lasch, *The Minimal Self*, London, Picador, 1985 p184

51. Gillian Skirrow, 'Hellivision: an analysis of video games', in Manuel Alvarado and John O. Thompson (eds), *The Media Reader*, London, British Film Institute, 1990 p336

In virtual reality technologies, these kinds of anxiety and ambivalence promise to be raised to new levels. How to face this Medusa? The power of these new technologies stirs up turbulent feelings of desire and fear. The fantasies associated with entering 'into' this image space can reactivate infantile feelings of regression, and omnipotence illusions. What will happen 'inside' this fantasy space? What will happen if the 'outside' world loses its reality?

Hostile vision:
simulation, surveillance – and strike

On the evidence of the games the preferred male solution seems to be to bury themselves in the mother's body with their phantasy weapons and forget about the very real dangers in the world outside until these dangers manifest themselves as disputes about boundaries, as in the Falklands 'crisis', in which case they can be understood and dealt with by playing the war game, again.

Gillian Skirrow

In all the outpourings about the humane and creative potential of virtual reality technologies, there are occasional references to the pioneering role of NASA and the US military. Little is made, however, of the significance of military research and development. Simulation technologies are simply and straightforwardly welcomed as a spectacular and beneficial 'spin-off' from the military project. What is not acknowledged is the scale of military involvement in this techno-logical domain; it has been estimated that the US military alone accounts for about two-thirds of the global simulation and training market.[52]

There has been little recognition of how extensive the role of simulation technologies has become in military activities, from training, through battlefield modelling, to combat management. What, then, is the nature and significance of the military development of vision technologies? In looking at first, simulation technologies and, then, surveillance systems, I want to suggest how fundamental they have become to contemporary military strategies. The Gulf War provided the show case. What I also want to consider are the broader social implications of this militarization of vision. What are the cultural, ethical and psychological consequences of the military-cybernetic project?[53]

A US army colonel argues that the conditions of modern warfare require advanced modelling capabilities. One such technique he describes as 'virtual prototyping', that is to say the creation of 'an engagement simulation of a battlefield, complete with friendly and threat systems.' This would allow developers to:

hypothesize a notional system and assign it certain technical parameters. The characteristics of that notional system can then be placed into a simulation and fought in a variety of scenarios. The operator of the notional system would be trained just as if that system were real.[54]

The virtual prototype is a simulation game, a kind of war game. Like other kinds of game, this is a closed world, with its own internal logic and formalized rules. Like other computer games it is a microworld. And the point about microworlds is that whilst they are internally consistent, they are 'simpler than the open universe of which they are a partial model'; and this simply means that they 'cannot recognize or address entities or processes beyond those that are given or taught to them.'[55] The key question, then, concerns the significance of this ontological closure.

What becomes clear with military simulation is that the relation to the wider universe (what we should still call the real world) remains fundamental. In certain applications it might seem as if the simulation were 'pure', that is to say self-contained. The virtual prototype appears to be simply a hypothetical model. But it is increasingly the case that the simulation itself has become a strategic element in real world confrontations. In the case of possible nuclear war, for example, the real consequences of engagement are terrifying:

Thus the technological preparations and logistical analyses assume the atmosphere of a game, whose object is for each side to try to produce and maintain a winning scenario, a showing that victory is theoretically possible, a psychological and political effect. It is not so much a true standoff or 'deterrence' as a simulation of a standoff, an entirely abstract war of position. Like a video game, the object is not to win but simply to continue the race as long as possible, at ever-increasing speeds.[56]

A good example is the simulation testbed being developed for the Strategic Defence Initiative (SDI). If it is not feasible to test SDI 'in a full deployment model', what is possible is the simulation of 'sensor and battle management algorithms', with this simulation itself then functioning as a gaming strategy.[57]

At the same time that simulation becomes a weapon of 'real world' military strategies, what we also see is the tendency for real wars, when they are waged, to assume the appearance of a simulation. There is a *derealization* effect, which makes it *seem* as if the war is being conducted in cyberspace. The scale and speed of contemporary war are associated with an intensification of what Paul Virilio calls the 'logistics of perception'. 'The bunkered commander of total war suffers', he argues, 'a loss of real time, a sudden cutting-off of any involvement in the ordinary world.'[58] Simulation then becomes the form in which military activities are represented and, for the commander, involvement in those activities is a question of interaction with this simulated image. Even for the unbunkered fighter pilot, the experience of combat becomes derealized: the US Air Force is reported to be currently developing a Virtual Reality Helmet 'that projects a

52. Sandra Sugawara, 'Tough times for trainers', *Washington Post-Washington Business*, 10 September 1990

53. See Les Levidow and Kevin Robins (eds), *Cyborg Worlds: The Military Information Society*, London, Free Association Books, 1989; Kevin Robins and Frank Webster, *The Technical Fix*, London, Macmillan, 1989 ch8

54. Colonel John Alexander, 'Antimaterial technology', *Military Review*, October 1989 pp38-9

55. Paul N. Edwards, 'The closed world: systems discourse, military policy and post-World War II US historical consciousness', in Levidow and Robins, op.cit. p154

56. Paul N. Edwards, *Artificial Intelligence and High Technology War: The Perspective of the Formal Machine*, Working Paper no6, Silicon Valley Research Group, University of California, Santa Cruz, November 1986 p31

57. See Joseph A. Kress, 'US army simulates SDI battle management', *Defence Computing*, July-August 1988

58. Paul Virilio, *War and Cinema*, London, Verso, 1989 p65

cartoon-like image of the battlefield for the pilot, with flashing symbols for enemy planes, and a yellow-brick road leading right to the target'.[59] It is as if the simulation had effaced the reality it modelled. As if commander and fighter were engaged in mastering a game logic, rather than involved in impassioned, bloody and destructive combat. It is 'as if' this were the case but, of course, the truth is that it is not: mastery is an illusion, and reality always threatens to break through the simulation. The case of the USS *Vincennes*, which shot down an Iranian Airbus in 1988, is graphic. For nine months before it went to the Persian Gulf, the crew trained with simulated battlefield situations. The overflight of civilian airliners, however, was not included in the simulation, and with the reality – the very unsimulated reality – of the Airbus on 3 July, the *Vincennes* could not cope:

nine months of simulated battles displaced, overrode, *absorbed* the reality of the Airbus and electronic information of the moment. The Airbus disappeared before the missile struck: it faded from an airliner full of civilians to an electronic representation on a radar screen to a simulated target. The simulation overpowered a reality which did not conform to it.[60]

When it intruded into the military microworld, when its reality transgressed into the simulation, the implications for the airliner were fatally real.

The power of the simulation should not deceive us into believing that war is now a virtual occurrence. If military simulation reminds us of a video game, we should recognize that its objectives go far beyond symbolic mastery of the screen. We should remember that the simulation is a model of the real world, and that the ultimate objective is to use that model to intervene in that world. It is precisely the functions of telepresence and teleoperation that are crucial in this context. The computer simulation technology is part of a cybernetic system, which includes sensors and weapon systems, to remotely monitor, and then to remotely control, real world situations and events. If one agenda concerns the so-called man-machine interface (questions of ergonomics and interactivity), another concerns the interface between the simulation technologies and the real world. It is here that the technologies of surveillance become crucial.

Surveillance has, it is well known, been integral to the evolution of photography. Through being photographed, things become part of a system of information which then opens up enormous possibilities of control. And new technologies have always been sought to enhance this capacity to monitor and record, to make it more extensive, more intrusive, more systematic, more furtive. The fundamental development in this trajectory of photographic surveillance was, undoubtedly, the externalization of vision through aerial reconnaissance and intelligence.[61] What began in the nineteenth century with camera-carrying balloons has now culminated in the orbiting vision of surveillance satellites. And, of course, it is the military, above all, that has sustained this surveillance culture. 'From the original watch-tower through the anchored balloon to the reconnaissance

aircraft and remote-sensing satellites,' Paul Virilio emphasizes, 'one and the same function has been indefinitely repeated, the eye's function being the function of a weapon.'[62] It is to the information needs of the military that we can attribute the new generation of ultra-high resolution cameras and other remote-sensing technologies; to its intelligence needs that we can ultimately attribute the new digital technologies of image processing and manipulation. The development of space reconnaissance has been associated with the increasing militarization of vision.

Satellite surveillance technologies, euphemistically described as 'national technical means' (NTM), have been one of the most fundamental military developments in the twentieth century. The origins of the programme were in the 1960s when, in the context of the Cold War, there was a 'need to know' what was going on in the 'evil empire' behind the Iron Curtain. The programme was driven by the dream of 'being able to look down on events happening perhaps halfway around the world and watch them from right up close, virtually as they happened, the way an angel would.'[63] For a long time this panoptic ambition was frustrated by the low resolution of the images produced and by the indirectness and inconvenience of having to parachute film pods back to earth.

The real breakthrough came in the mid 1970s with the launching of the KH-11 series of satellites which use charge-coupled devices to transmit digital signals back to a receiving station at Fort Belvoir in Virginia, and thence to the CIA's National Photographic Interpretation Center in Washington, DC. The KH-11 is like a television camera in space, and is able to combine near real-time monitoring capability with high resolution images (probably six inches across). Subsequently this keyhole series of satellites has been enhanced by a new generation of technologies that allow them to 'see' at night and to 'penetrate' through cloud cover. The so-called Lacrosse satellite, launched at the end of 1988, uses radar imaging to provide all-weather day and night coverage. The enhanced KH-11 (sometimes called the KH-12) was launched in 1989 and has infra-red imaging capabilities for night-time surveillance. It is believed that currently the US uses two KH-11s, two Advanced KH-11s and one Lacrosse (although the relationship between the Advanced KH-11 and the Lacrosse remains unclear).[64]

In addition to the $5 billion that the US invests in space reconnaissance each year, there is now a growing commercial involvement, particularly with the development of the French SPOT programme. There is a constituency which sees this development as beneficial, opening the way for independent arms control verification and also for crisis monitoring (Chernobyl, oil slicks, and so on).[65] It appears, however, that the line between commercial and pacific applications, on the one hand, and military applications, on the other, has become extremely thin. SPOT advertisements have promoted military applications, promising to provide the technical means for 'a new way to win' to those who buy its intelligence. It is also the case that military agencies are turning to

59. Evan Thomas and John Barry, 'War's new science' Newsweek, 18 February 1991 p21 cf. 'The military is experimenting with pilot's helmets that display a computer-enhanced, real-time landscape on the visor, with the pilot, in real or simulated flight, issuing voice commands like "select", "zoom", "god's eye", "fire". Instead of an arm for a pointer, the pilot points his eyes. "Fire": the definitive piercing glance.' Brand, op.cit. p139

60. James Der Derian, 'The (s)pace of international relations: simulation, surveillance and speed', Paper presented to the BISA/ISA Meeting, London, 28 March – 1 April 1989 p10

61. See, for example, Rupert Martin (ed.), The View from Above, London, Photographers' Gallery, 1983; Peter Mead, The Eye in the Air, London, HMSO, 1983

62. Virilio, op.cit. p3

63. William E. Burrows, Deep Black: Space Espionage and National Security, New York, Random House, 1986 p226

64. Jeffrey T. Richelson, America's Secret Eyes in Space: The US Keyhole Spy Satellite Program, New York, Harper & Row, 1990; Jeffrey T. Richelson, 'The future of space reconnaissance', Scientific American, January 1991; Andrew Wilson (ed.), Interavia Space Directory 1989-90, Geneva, Interavia SA, 1989 pp288-91

65. See Bhupendra Jasani and Toshibosmoi Sakata (eds), Satellites for Arms Control and Crisis Monitoring, Oxford, Oxford University Press, 1987; Michael Krepon, Peter Zimmerman, Leonard Spector and Mary Umberger (eds), Commercial Observation Satellites and International Security, London, Macmillan, 1990; Tomas Ries and Johnny Skorve, Investigating Kola: A Study of Military Bases Using Satellite Photography, London, Brassey's Defence Publishers, 1987; Peter Zimmerman, 'A new resource for arms control', New Scientist, 23 September; Michael Krepon, 'Peacemakers or rent-a-spies?', Bulletin of the Atomic Scientists, September 1989

commercial satellites to supplement their own intelligence activities. In the face of proliferating military agendas – early warning, target location, damage assessment, anti-terrorist applications – it would seem that international peacekeeping and monitoring functions will only come a poor second. Transparency from space, I would argue, is more likely to sustain the military information society than to undermine it.

The details of space reconnaissance and surveillance technologies are arcane and shrouded in secrecy. The point, however, is to be clear about the scale and the implications of military vision. As to the scale, it is estimated that the US can now monitor 42,000 separate targets around the globe. This surveillance is also increasingly a matter of continuous vision, 'revisiting' targets in order to monitor significant change, watching through all weathers, round the clock. The earth is thereby 'becoming encapsulated by whole networks of orbital devices whose eyes, ears, and silicon brains gather information in endless streams and then route it to supercomputers for instantaneous processing and analysis – for a kind of portrait of what is happening on planet Earth painted electronically in real time.'[66] That is the manic ambition for these 'national technical means'.

If the very scale of military intelligence activity is itself alarming, there are broader implications to these developments. This is the way in which optical technologies have come to function within total weapon systems. Surveillance and simulation technologies feed off each other. And surveillance and simulation technologies together feed into the control of a new generation of 'smart', vision-guided strike weapons. Thus, the most advanced surveillance satellites are involved not only in active reconnaissance, but also in digital terrain mapping. The US Defence Mapping Aerospace Agency is currently involved in producing digital data bases of the earth's surface, and these are then used for such applications as mission training and rehearsal simulation, plotting low-altitude flight routes, missile navigation, and precision weapon-targeting. Perhaps the ultimate achievement to date has been the Tomahawk Cruise missile. For most of its lethal journey, the Tomahawk navigates through a radar altimeter which compares the topography of its flight path against detailed computer maps stored in its memory. As it reaches its 'terminal end point', a new guidance system takes over, with a small digital camera comparing the view from the nosecone against a library of stored images prepared from earlier satellite photography of specified targets.[67] The space-defence systems that are currently being developed are simply the ultimate extrapolation of this systemic approach to weapons technologies. The Strategic Defence Initiative has been described in terms of the cohesion of Surveillance, Acquisition, Tracking and Kill Assessment (SATKA).[68] It is about the total co-ordination of surveillance, simulation and strike technologies to ensure military omniscience and omnipotence.

What I want to emphasize are the ontological implications, and then the ethical consequences, of this military cybernetic project. The new systems of

surveillance, simulation and strike technologies operate across and through two different levels of reality, the virtual and the material. It is the split between these two realities, I would argue, that underpins the contemporary experience of existential dislocation and moral disengagement. It is right to observe that there has been a kind of derealization of military engagement: postmodern warfare is, indeed, increasingly a mediated affair, characterized by simulation, telepresence and remote control. But this insubstantial and synthetic reality has an interface with another reality that we are still right to call our real world. This world is defined as the world of targets; new satellite images can turn entire countries into targeting information (into 'target-rich environments').

When these targets are 'taken out', however, they scream; and when they are 'neutralized', they bleed. The commander and the fighter are beings in the world. They have bodily existences, and they should understand the realities of pain and suffering. They live in a universe of moral obligation, and they should be aware of their ethical responsibilities and obligations. But they also live and exist otherwise. They also function as components in the virtual domain of the military technological system. And within that system, they have a disembodied existence: they operate at a purely cognitive level, and their engagement with the real world becomes indirect, mediated through the images on video screens. Within the system of that microworld, existential and moral questions are meaningless: 'Though individuals inside a military system do make decisions and set goals, as links in the chain of command they are allowed no choices regarding the ultimate purposes and values of the system.'[69] The logic of the system prevails over individual and social morality.

The video-game player is 'apparently a double or a split subject since the game is simultaneously in the first person (you in the real world pressing keys) and the third person (a character on the screen, such as a knight, who represents you in the world of fiction).'[70] The military game player is, similarly, a double or a split subject, a first person pushing buttons and a third person involved in the combat on the screen. But with the military commander and fighter there is a more disturbing dimension to this splitting process. James Grotstein describes psychotic behaviour, in which the psychotic 'may projectively identify a split-off, disembodied twin self who is free to move about at will, leaving the body self abandoned.' This, he argues, 'is a defence mechanism which, at its most benign, postpones confrontation with some experience that cannot be tolerated, but which at its worst can negate, destroy, and literally obliterate the sense of reality.'[71] This is highly suggestive. The psychoanalyst, Hanna Segal, also observes this psychotic tendency. In contemporary military activity, she comments, 'there is a kind of prevailing depersonalization and de-realization. Pushing a button to annihilate parts of the world we have never seen is a mechanized split off activity.' 'This obliteration of boundaries between reality and fantasy', she believes, 'characterizes psychosis.'[72]

66. Burrows, op.cit. p306

67. 'The mind of a missile', *Newsweek*, 18 February 1991 pp22-5

68. Neville Brown, *New Strategy Through Space*, Leicester, Leicester University Press, 1990 pp73, 78

69. Edwards, op.cit. 1986 p26

70. Skirrow, op.cit. p330

71. James S. Grotstein, *Splitting and Projective Identification*, New York, Jason Aronson, 1981 pp131, 138

72. Hanna Segal, 'Silence is the real crime', *International Review of Psycho-Analysis*, vol14, no2 1987 pp7, 9

To be Sergeant Able F. Cooper

Humankind lingers unregenerately in Plato's cave, still revelling, its age-old habit, in mere images of the truth.

<div style="text-align: right">Susan Sontag</div>

What I want to address, in conclusion, is the relationship between image technologies and vision cultures. More specifically, I am concerned with what the developments I have been looking at in this chapter tell us about the western culture that has spawned them. Images have a particular resonance in this culture and they have been used in particular ways, for particular objectives.

Two broad agendas can be said to have shaped and defined western self-identity. The first has been the principle of scientific and technological rationality: 'Modern western culture is, in short, the rational, self-rationalizing and rationality-conscious culture par excellence.' The second has been 'a uniquely intensive confrontation with other cultures', that is to say the imperial and post-imperial encounter with non-western societies.[73] In this encounter, the West has always resisted the recognition of its own difference and particularity in favour of justifying its successful domination on the basis of the superior, that is to say universal, truth of its values and its project. What Georges Corm calls the 'Narcissistic history of its modernity', is rooted in the passionate belief that, whilst non-western cultures are eternally frozen in the Dark Ages, 'the flowering of its own civilization was the founding moment of universal modernity.'[74] And that modernity was precisely about the harnessing of science and technology to human progress. Technological rationality has been fundamental to the justification and legitimation of western hegemony over other cultures.

This presumed reciprocity of technological superiority and cultural supremacy is quite clear in the discourses surrounding the new image technologies. There is a tendency, as I have argued, to consider the end of chemical photography and its replacement by digital image technologies as straightforwardly a matter of scientific and technological progress. There is the common sentiment that, like other technological innovations, these new electronic techniques will enhance human possibilities and potential – in this case, that they will create new kinds of vision, other ways of seeing, alternative worlds of experience. This progress is associated with processes of *universalization*: the computer is the *universal machine* and the images it generates are a *universal medium*. According to Pierre Lévy, the universal machine subsumes all earlier and all other cultures. If, he argues, 'we take into account the appearance of a new temporality; the leap in storage and processing capacity; the redefinition of knowledge and know-how; the change in behaviour, sensibility and intelligence; and also the universal scope of the information culture, then comparison with the shift from pre-history to history does not seem absurd.' The universal machine, in which all cultural forms are

translated into the same digital language, brings us to the moment of 'post-history.'[75] Insofar as it provides the logical structure for culture in general, and for each art form in particular, it represents the supreme vindication and fulfillment of western culture. On this basis, it becomes possible to imagine what one writer calls 'a new informational economy of interculturalism.'[76] With the development of new information and cybernetic technologies, all cultures and cultural forms converge, and are harmonized within the universal discourse of western rationality.

What are we to think of this post-history? Are we persuaded by these claims to universalism? In the nineteenth century, chemical photography was hailed as the first universal language. We can see more clearly now how those old photographic technologies reflected the vision and the values of western culture. In the name of universalism, they were mobilized against, and intruded into, other cultures. It is difficult to believe that it could be otherwise with the new digital electronic technologies. Their development is also associated with the attempt to constitute the coherence of western culture and, in so doing, to constitute and assert its superiority. The West 'can only be a name for a subject which gathers itself in discourse,' one that 'continually seeks itself in the midst of interaction with the Other.' In so doing, the West strives to 'represent the moment' of the universal…the universal point of reference in relation to which others recognize themselves as particularities.' The non-West has to be 'a mirror by which the West becomes visible.'[77] The success of this hegemonic strategy is, of course, always problematical, particularly when the Other comes to question and contest this asserted universality, and when it comes to compete with that technological supremacy that is supposed to be the basis of western universality. (This is the case now with Japanese vision and image technologies. Has Japan become drawn into western universalism? Or is it actually the 'non-West' challenging western identity and its hegemonic foundations?)

When we look at this new so-called universal medium, we can see that it, in fact, reflects, and reinforces, a *particular* vision culture: like nineteenth-century photography, it too is western-eyed. Through the course of empire, the image has monitored and documented 'alien' populations. From nineteenth century anthropological records through to the recent photo-reconnaissance of the Middle East, observation and control have always been closely related. The other is diminished by the look. And, at the same time, the West's superiority seems to be confirmed.

For western culture – the culture of Enlightenment – knowledge is associated primarily with vision (illumination). Vision is the most detached (perhaps we might say the most deaf) of the senses, underpinning the ideal of objective and scientific (value-free) knowing. It is the eye that penetrates to the essence and truth of things. On this basis, it then becomes possible to believe that superiority in vision (that is to say in vision technologies), is itself a reflection of the inherent supremacy of western civilization. A small example from the Gulf War reveals

73. Johann P. Arnason, 'Culture and imaginary significations', *Thesis Eleven*, no22 1989 p34

74. Georges Corm, *L'Europe et L'Orient*, Paris, La Découverte, 1989 pp372, 373

75. Pierre Lévy, *La Machine Univers: Creation, Cognition et Culture Informatique*, Paris, La Découverte, 1987 pp42-3; cf. Pierre Lévy, 'La machine universelle', *Terminal*, no27-8, April-May 1986

76. Frederick Turner, 'The universal solvent: mediations on the marriage of world cultures', *Performing Arts Journal*, no35/36 1990 p93

77. Naoki Sakai, 'Modernity and its critique: the problem of universalism and particularism', *South Atlantic Quarterly*, vol87 no3 1988 p477

this claim to universal reason, and also the orientalist attitude concealed in the discourse of vision. Saddam Hussein was accused of keeping his equipment 'under wraps'. The implication was that he was deceitfully avoiding the scrutiny of vision and the light of truth:

> Saddam Hussein's armies last week seemed to be enacting a travesty of the Arab motif of veiling and concealment. In the Arab world, women often veil themselves not because they are punished or shamed but because women, who produce life, must be protected, as a plant in the desert might be. Houses turn inward, the living quarters hidden. The true treasures are concealed. Saddam similarly appeared – or wished to appear – to be masking his strength, hiding it in bunkers in the sand.

In contrast, the report emphasizes that 'Generals and Presidents need a clear eye for the truth.'[78] No doubt the spy satellites out in the 'deep black' helped to make that eye more clear.

When we talk about an imperialism of the image now, however, we may mean something different: we may also be referring to the hyper-real proliferation of images in these times. We are then expressing our feeling that images have become an autonomous force, a power in their own right; and we are articulating a belief that older realities, and senses of reality, might become eclipsed by this power of the image. The image, it seems, has itself become the substance of a new world, a virtual (and wishfully virtuous) world. An awareness of this uncharted land stirs an atavistic western reflex: the desire, even the need, for discovery, exploration and colonization. Techno-explorers now gaze upon this factitious landscape as Cook must once have surveyed the *tabula rasa* of Botany Bay. Or, as one commentator puts it, invoking a different forbear, 'Columbus was probably the last person to behold so much usable and unclaimed real estate (or unreal estate) as those cybernauts have discovered.'[79] In this technologically unreal estate everything seems possible. It is like the Torec in Primo Levi's story, *Retirement Fund*:

> You understand: whatever sensation one might wish to obtain, one only has to pick a tape. Do you want to go on a cruise to the Antilles? Or climb Mount Cervino? Or circle the earth for an hour, in the absence of gravity? Or be Sergeant Able F. Cooper, and wipe out a band of Vietcong? Well, you lock yourself up on your room, slip on the helmet, relax and leave it to him, to the Torec.[80]

This is, indeed, a brave new world.

Only it is not a new world. Everything is strangely familiar and very unsurprising. For this is no more than a virtual extension to our habitual western civilization. This is a world of omnipotence fantasy where to be or to do something it is only necessary to wish it. It is a world outside of morality where we can all be Sergeant Able F. Cooper without facing the consequences. In this timeless world we can play out our most unreasonable fantasies. There is nothing

culturally innovative in this. But this is the image world that our western narcissism recognizes and is drawn, in fascination, to embrace. As with the Torec, 'while the tape lasts, it is indistinguishable from reality.' We can try, our age-old habit, to linger inside the image. But when the tape stops, that other reality is still there waiting, with all its discontents.

78. Lance Morrow, 'The fog of war', *Time*, 4 February 1991 p13 cf. Foucault's comments on Enlightenment ('the dream of a transparent society' and 'the fear of dark-ened spaces'), in his essay, 'The eye of power', in Michel Foucault, *Power/Knowledge*, Brighton, Harvester, 1980

79. Barlow, op.cit. p37

80. Primo Levi, *The Sixth Day*, London, Michael Joseph, 1990 p110

Jeremy Welsh

med

repr

to eno

Jeremy Welsh was born in
1954 in Gateshead, England.
He is the Exhibition/
Distribution Director at
London Video Arts and a
Director at the Film and Video
Umbrella, London. Currently
Head of Intermedia
Department, Kunstakademiet I
Trondheim, Norway, he is a
practicing video and media
artist and writer on video arts.

I'm the transmitter
give information
You're the antenna
catching vibrations.

Kraftwerk C, 1976

anical
oduction
ess
eplication

It is said that in certain parts of New York, on the tops of tall buildings belonging to corporations who transmit data between sites by micro-wave, that roosting birds are sometimes *cooked by data*. Television signals, computer information, text or graphics.

She looks, 1991
Computer image created on Apple Macintosh. Still frame from video 8 treated through Nuvista
Capture and Adobe Photoshop

Photographs perhaps? Killed by images.

Click

We have all watched the television pictures from Baghdad and pored over the grainy reproductions of video stills in the newspapers. We have seen the evidence that people are killed by 'intelligent bombs'. We have seen the absolute interpenetration of our physical world and the virtual world of digital information. We have watched the bomb fly to its target from the viewpoint of the pilot who launched it. Next time television will no doubt arrange for us to see the process from the point of view of the bomb itself. How will the faces of those victims look as they realize that they are about to be killed by a flying camera?

Click

Anything can be a camera. In three-dimensional modelling programmes for computers, 'objects' are designed in a virtual space. An object has three dimensions, all of which can be viewed by swivelling it around in its simulated environment. However, it

does not stop there. The object itself can be a camera and we can explore the simulated world from that object's point of view. We, of course, remain on the outside, viewing the object's world through the video screen, but we can navigate the 'camera' and use it as a surrogate for our own eyes. When we extend this process further, with virtual reality tools like the 'data glove' or 'eyephones', we reach the point where we all but physically enter this simulated space. It is quite imaginable that in the course of exploring a virtual environment we come across any number of images that have lodged themselves there – clones of clones of images that, once digitized, are not in any sense fixed any longer and may thus 'haunt' the interior world of digital memory, waiting to rematerialize somewhere. (And perhaps they pass the time by cooking pigeons.)

Polaroid

I'm in a room with no windows and 444 television channels. I have a remote control in my left hand and a remote control in my right hand. The television is on. The video is on. The computer is on. The fax is on. Press/Rec/Play/Pause. Finger on

the button. Wait for the moment. *That* moment. The moment when, out of the fog of data emerges an image of sudden clarity. An image that locks itself in the memory. A (meta)narrative unfolds/enfolds. We live in a vortex of spinning fragments. We're like shards of spinning glass in the gyroscopic window of some cosmic kaleidoscope. We converge, diverge, form fabulous patterns that dissolve, decay, dissipate and reform. We're like little icons shaken loose from our frames and we tumble and spin through a false space of fractal illusion. We live in a space constructed from data, from images, from samples. We are part of the furniture. Someone is watching us but we do not know who or where (or why), but our image is part of someone else's input. It is not so much the case anymore that we will all be famous for fifteen nanoseconds. On the contrary, cameras make us anonymous, *permanently*. Surveillance is a technology designed to convert people into data. And data is data is data, living or dead.

Scan

Images held in digital memory are in some sense the living dead – deprived of physical manifestation. Photography was to be the

death of painting, which somehow survived, mutated, incorporated its assassin and is now slipping out of its material skin to be reincarnated once again in a digital form. The living death of photography, beyond the digital process, is another stage of evolution. The photographic process is updated yet, in some sense, remains the same. Before we had a chain of consequent events beginning with a roll of unexposed film and ending with a set of prints. Now we can begin with a blank magnetic disk and end with a visual data base of thousands of images accessed via computer from a videodisc player or some other mass-storage device. We can, of course, still have the print too. This way we get to have our cake and eat it, but somehow it seems to be the wrong cake – instead of satisfying it just makes us hungrier.

Photocopies

Let us consider Images as Traces, the archaeology of the Insubstantial, the gaps in the flow of oversignified information. The accidental signs and ciphers that invite other ways of reading the environment. The unintentional graffiti of decayed information – the chance graphics of decay and renewal that can be witnessed

in streets, anywhere, anywhere at all. A certain dream that is expressed equally through the passage of time on a journey, when the world slips by, untouchable and illusory and the passage of time in the succession of images that appear to offer a world, a set of worlds, packaged for consumption. Is the choice merely to consume or be consumed by?

Captions

Language and Slippage and Impossibility…the collision of languages, the slippage of meaning, the impossibility of fixing points on a map whose scale is anyway inexpressible. A map that precedes the terrain it represents. A map which, if folded, would fold in on itself infinitely, like a torus, a fractal, a recurring decimal – folds within folds giving upon a dizzying and vertiginous perspective of endless replication.

Postcards

The Aesthetics of Disappearance – virtual images – images on the edge of being there – images at the edges of memory – images

with no meaning, no place in the discourse of *Information*, no exchange value in the Commodity Signifiers market. *Used* signs, like used cars, used refrigerators; signs abandoned, left to rust, left to subside into, be subsumed into the corrosion of obsolete meaning. Things that can be missed in the blink of an eye, the *click of a shutter*. Or else, things that *only* appear in the blink of an eye, things that are only, always…**almost there**. The ghosts. The traces.

Family albums

Old black-and-white photographs, when digitized, take on a power that is entirely missing from the modern full-colour image. Perhaps because they were already ghosts, traces, memories – they already know how to exist in the virtual world and need make no claim on 'objective reality' whereas the colour photograph of today screams out for recognition as a 'real' thing – even as it slips into the swamp of hyper-reality. In an introductory interview to his video tape 'Art of Memory', screened in the BBC2 series 'White Noise', the American artist Woody Vasulka talks of the necessity to stop looking forward in the late-twentieth century, but to look back, to use memory, to recognize what has happened

in this technologized century. His mutated black-and-white images writhe and float through livid, red desert landscapes. The double metaphor of desert as a place of remembering and the photographic image as a trigger to memory combine within the simulated space/time of video to create a visual language born out of memory, yet apt to describe the present or to envision the future.

Travel guides

We have become like tourists in our own towns and cities, our homes and families, *our own bodies and memories*. We read magazines that tell us what we are while we wait for the bus, the train, the plane that takes us to what, where and who we will be. We gather fragments of stories, fragments of images, fragments of information, of data…we collect, we archive, we rename and re-use. We adorn ourselves with fragments, our culture becomes a car, a carg, a cargo, a cargo cult a cargo culture.

TV shopping

A cargo culture…a commodity culture…a renewable culture. All

must be renewed, renewable. Memory will be strictly short term, random access, volatile. As much as *Museums* (repositories of Memory) we are building endless Transit sites (engines of forgetting) for the exchange of articles with **no past** and **no future**. Articles that lose their value as soon as the packing is removed and lose their meaning when the batteries run flat. Articles that are always less than their own image – of less interest than the packaging they arrived in.

Virtual archaeology

A paradox. We are archaeologists, curators, antiquarians, collectors of relics. But we don't care if we fill our museums with fakes. We don't care because there is no longer a distinction to be made. We don't care because all the real things are fakes – they turn into fakes under our gaze, our gaze is a faker.

Self portrait

I catch myself looking at my own reflection, I am audiencing my own performance. In the realm of self reflexivity, Performance is

the Act of Being – Being one's own eyes as it were – and each moment is a construct, each gesture a signifier. We speak the language of The Look – our action is that of **Framing**. The glance is a freeze frame. What I want is affirmation – **HARD COPY**. But I also want control, the tools to **edit**. A new image, new features, new skin colour – just like those computer graphic programmes used by certain hairdressing salons to simulate hairstyles on digitized images of their clients.

Virtual pornography

In *The Atrocity Exhibition,* J.G. Ballard's descriptions of the erotic conjunction of architectural spaces and body parts comes to life through the mediation of the screen and the digitized image. The voyeur reconstructs the object of sublimated desire by editing the image – to create the idealized erotic icon, composed only of those elements that excite the individual's unrealizable desires. The face of a film star, the windows of a supermarket, the ramps of a car park, the various body parts of anonymous models, athletes, politicians, entertainers. The composite image takes on a kind of artificial life. And is it possible that even the *data* that constitutes

this image is imbued with a sexual charge?

Index

I'm in a room filled with screens. I am receiving data from each point of the compass. I have a remote control in my hand and with it I command the screens to display a matrix of miniature images – a visual index of all the channels incoming. With a single push of a button I select a channel, search an image and transmit it to your terminal. It appears on your screen and moments later, a colour copy emerges from your printer. With an electronic stylus you mark changes to the image and transmit the data back. The re-edited image appears in my index and the sequence from which it came is automatically updated to accommodate the new image within a believable continuity. History is rewritten from moment to moment. The end of history, the end of memory, an eternal present whose duration is so short that time is virtually abolished.

The gap between transmitter and antenna is closed. They mirror each other's functions. To transmit is to receive is to transmit.

Mechanical reproduction to endless replication

Paul Wombell

6: 92

screen w

Computer intelligence applied to the battlefield is, for good or ill, transforming the nature of war.

Smart Weapons: Now and Future,
Ministry of Defence tape supplied by
Independent Television News, London

Listen carefully to General Colin Powell, the chairman of the Joint
Chiefs of Staff and himself a product of the Vietnam War, and the
vocabulary and mentality are the same. The principal weapons used
against Iraq, such as the Tomahawk cruise missile, have a 'circular
error probability'. This means they are targeted to fall within a
circle, like a dart landing anywhere on a dart board. They do not
have to hit, or even damage, the bullseye to be considered 'effective'
or 'successful'. Some have hit the bullseye - the Tomahawk that
demolished the Ministry of Defence in Baghdad is the most famous -

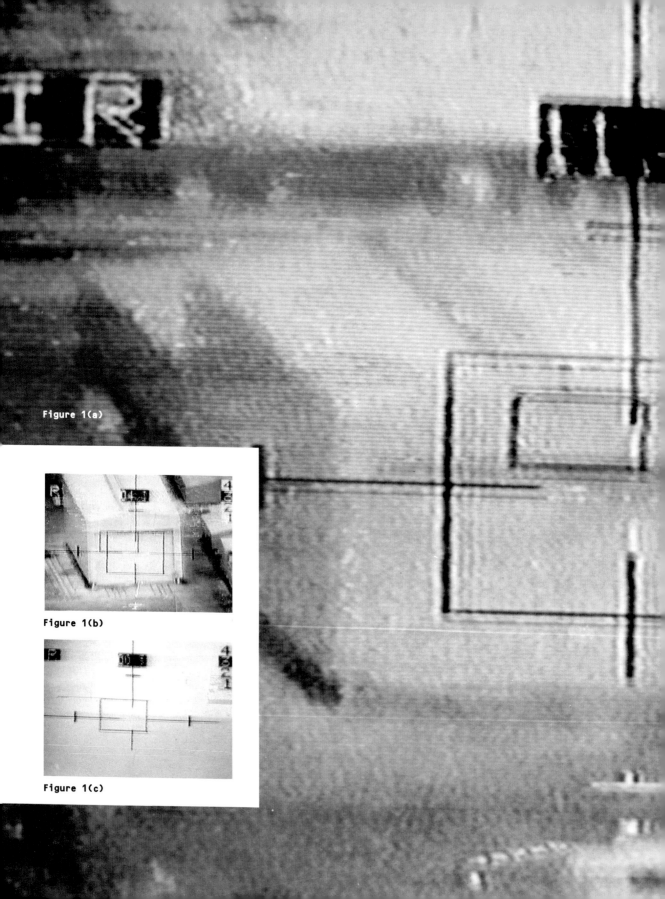

Figure 1(a)

Figure 1(b)

Figure 1(c)

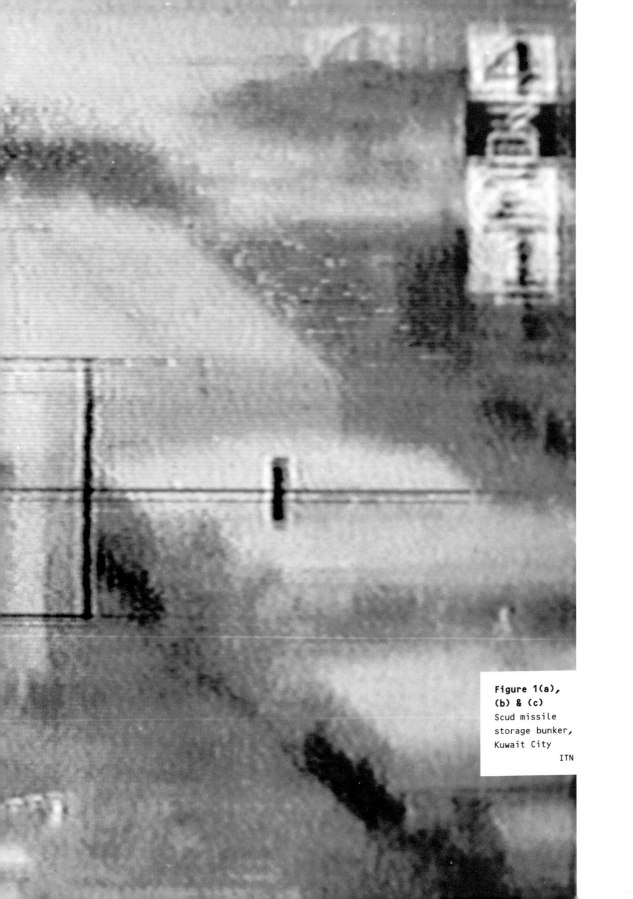

**Figure 1(a),
(b) & (c)**
Scud missile
storage bunker,
Kuwait City

ITN

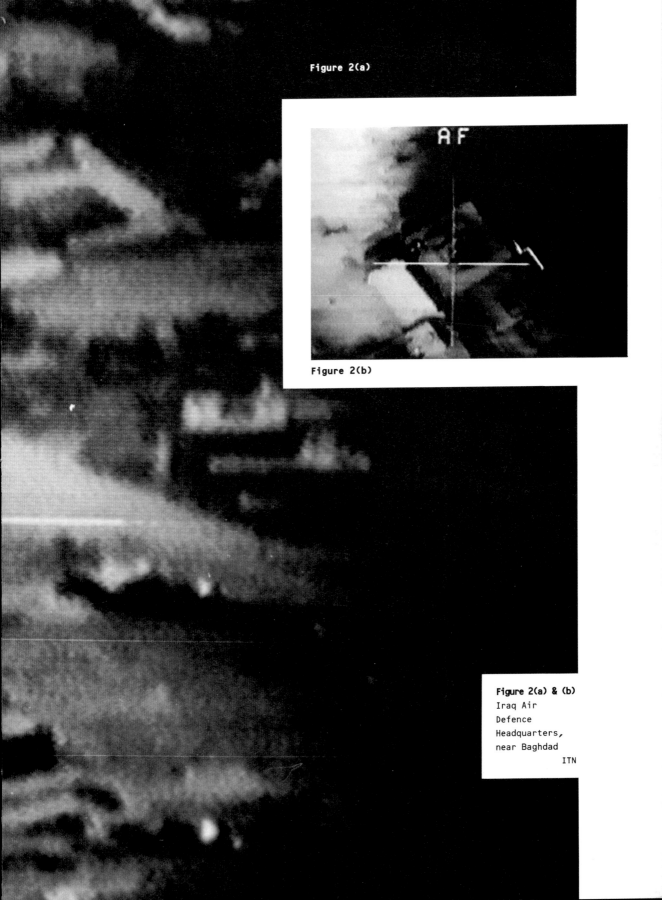

Figure 2(a)

Figure 2(b)

Figure 2(a) & (b)
Iraq Air
Defence
Headquarters,
near Baghdad
ITN

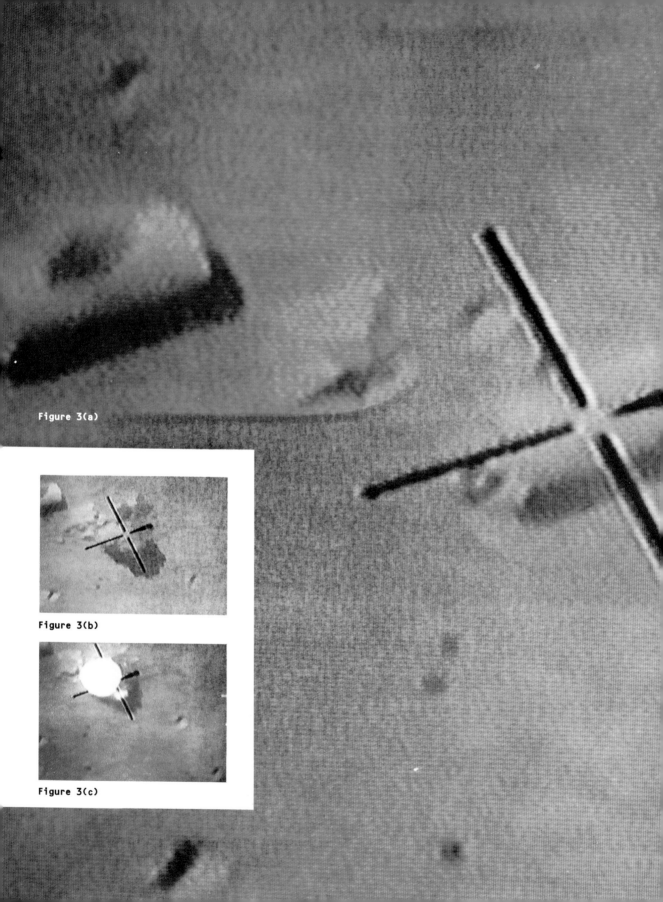

Figure 3(a)

Figure 3(b)

Figure 3(c)

Figure 3(a), (b) & (c)
Shows the effects of the unassisted 'dumb' bomb. Capable of select bombing that is of a direct hit suspending and destroying only those things contained in the target area, the bomb strikes an 'enemy' hardware shelter. Dumb bombing has particular advantages in some cases over what is known as 'blanket' bombing where everything within a certain radius of the explosion is destroyed.

ITN

Figure 4(a) & (b)
Cleared by the
US Military,
this image
shows an attack
on an hydro
electric plant
in Iraq. Taken
18 January 1991
and broadcast
on US news, CNN
21 January 1991.
An infra-red
video camera
mounted on the
'nose' of a
Stand-off Land
Attack Missile
(SLAM), relays
pictures of the
approaching
target and
surrounding
area, back to
the attacking
aircraft. This
allows the pilot
to make 'suc-
cessful' attacks
on 'key targets'.
Missiles released
from as far
away as ten miles
are guided by
computer memory
to the spot
marked by a cross
on the screen,
even after the
aircraft has
begun the return
journey to base.
Satellites aid
the missile by
fine tuning the
electronic signals
for accuracy.
ITN

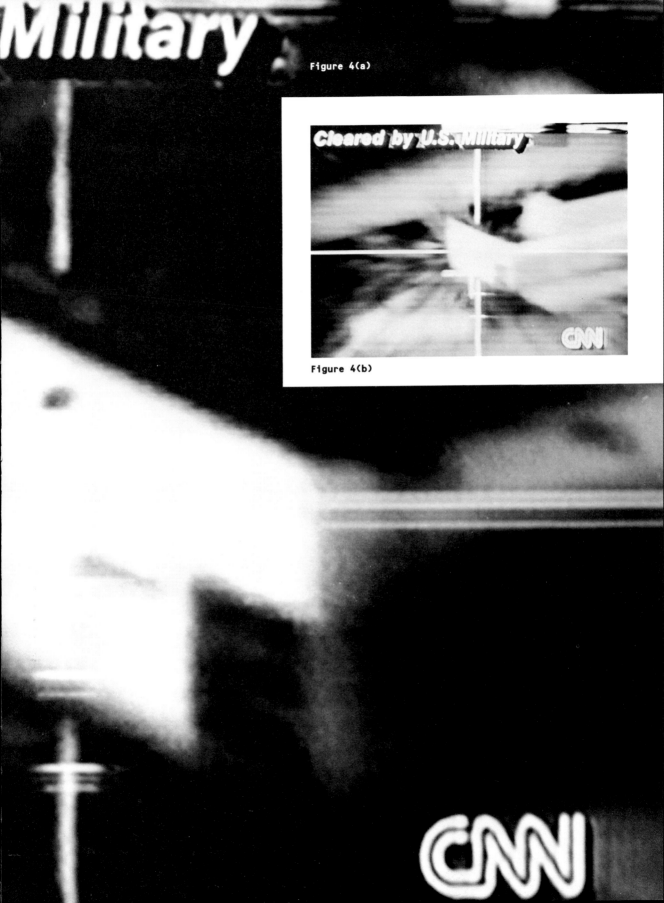

Figure 4(a)

Figure 4(b)

but many, if not most, clearly have not. What else have they hit? What else is within the circle? People, maybe? The autocues say nothing. The collusion of silence in the media is almost total.

(John Pilger, 'Video Nasties', *New Statesman and Society*, 25 January 1991)

Yesterday, the US released videotape showing precision attacks by an F-111 fighter bomber and the new F-117A stealth fighter. The weapons officer on board the F-111 steered two 2000-pound bombs, guided by laser beams, through the door of a Scud missile storage bunker in Kuwait, from a distance of two miles. The tape also showed the air defence headquarters near Baghdad, where a bomb went down an air shaft, and the air force HQ in the city where a bomb broke through the centre of the roof.

This clinical approach has been made possible through some of the most sophisticated electronic systems around, some of which were still being tested when they were put into action. The war in the Gulf, unlike any conflict before it, is being fought on the basis of data that is not only accurate, but also no more than a few seconds old.

This 'real-time' information travels from spy satellites via communications satellites to intelligence gatherers, then to military leaders and programmers. These people can be sure they have the most up-to-date information, for example on the success of previous missions, before they load fresh instructions into their missiles and send these to their targets.

At the heart of the Tomahawk cruise missiles, never before tested in the battlefield, lies an onboard database which holds three-dimensional maps of the terrain. The missile relies on a radar altimeter to tell it how high it is flying, and over what profile of land. It compares the information from the radar with that in its database almost continuously, to work out its exact position. The missile then adjusts its flight path by altering the gyroscopes on board, bringing itself back on course if it has strayed.

Such missiles, travelling at speeds of 500-600 miles per hour, can hit a target with an accuracy of a few tens of metres from a distance of more than 600 miles. This startling accuracy relies on information that programmers feed in before the Tomahawk missiles leave the ground. Some versions can even be reprogrammed once they are in flight. The programmes might include data such as the layout of roads, relayed from the skies.

Satellites including the American government's Lacrosse will be producing images of the Gulf terrain. Lacrosse is a radar imaging satellite which can distinguish objects between 15 and 20 yards apart. These are ideal for surveying the Gulf since the sandy desert provides radar images with far more impressive contrast than pictures of built-up areas.

The military will also be using the Landsat commercial satellites for general coverage and for the minutiae of tactical observation they will be making use of 'keyhole' satellites, advanced KH11s. These were launched from military flights of the Space Shuttle, and carry very powerful digital cameras thought to be capable of distinguishing objects just a few inches apart. The images these cameras produce, once enhanced by computer, could pin-point a coin in a soldier's hand.

(Susan Watts, *Independent,* 19 January 1991)

Graham Howard

multir cultural

Graham Howard was born in Winchester (UK) in 1948. He is an artist and designer and Director of Art of Memory Ltd, a company specializing in multimedia design and production. He was formerly Apple Head of Multimedia at Coventry Polytechnic and continues to teach at a number of institutions, including the Royal College of Art. He lives and works in the Cotswolds.

A multimedia family tree with photographs of family members, a voice recording of one family member talking about another, a video of others, can be easily understood and could be the way family albums will be in the future. You can wander around the family and structure its articulation of itself and develop it yourself, by putting in new multimedia events.

edia as product

Interactive multimedia

If you have not already, you will hear many different definitions of multimedia in the near future. Like many things, there is little point in trying to produce a water-tight definition; what we need is an understanding of an area of operation and some idea of the parameters surrounding it.

Multimedia is the bringing together of a range of elements, all familiar, into a new, technological configuration. It gathers together the visual image, whether it is graphical, photographic, animated or a mixture of these, with sound, text, video and data. We have considerable experience of these things being brought together in our ordinary lives, in many different ways and circumstances. Imagine talking to a friend in a pub about a photograph that you have seen in today's paper, there is chatter going on in the background, half heard conversations; you start to discuss the significance of the photograph and index it out to other photographs that you have seen in a television documentary; the pub television is put on for the news.

The reporter shows new footage of the conflict from which your original photograph was taken and suggests a new way in which the incident may be

Graham Howard and Kavita Sharma
Ambush

seen; you carry on discussing the photograph in the paper, referring to its accompanying text. You disagree about the cultural significance of the image and resume an earlier conversation whilst glancing at the bar television, where some of the video footage is being dissected and an animation is being shown to make 'things clearer'. This is a type of activity that we all understand, interactive multimedia represents such scenarios and situates them within the new technology.

Multimedia products are normally delivered on a CD and rely on a computer with a high-quality full-colour screen, full sound capability and preferably digital video, although instead of the latter there may be a controllable link through to a videodisc or videotape player. Previously this has meant that multimedia was only available to industry and education but now with the advent of domestic multimedia players, it will soon start appearing in the home. Multimedia is interactive and it is non-linear. You find your own way around and there are multiple paths for you to follow. As you follow a path, multimedia events happen; at some of these, the pathway will split into further pathways. Some of the pathways intersect at multiple points, others lead you to particular locations. Multimedia events can be sound, graphics, text, video or animation or any combination of these. Multimedia can be devised for a wide range of purposes, for business, for education, for entertainment. Multimedia's non-linearity makes it ideal for revisiting aspects of a topic and also to revisit at different levels the same topic. We might imagine studying a photograph and consider at which level we wish to look at it, technical/hardware, political post-Benjamin, conceptually, economically, domestically, etc., and then recognize that to really come to grips with the implications of the image we are forced to consider all these and others as well.

Looking at photographs

When we first come across a photograph and look at it, we go through a whole selection of processes. We may recognize the image of a family member, we may comment on its likeness to the person photographed; this with all its baggage of the ontological and cognitive status of the image. We may describe it as a 'good picture' of the person or the landscape, which often is a covert way of saying that the image is made vivid by the way it has been embedded within a certain representation. We might explore the image for clues of something we understand, especially if that image is of something unfamiliar to us. As we explore we try out different interpretations and different strategies for interpretation and we contextualize and recontextualize our attempts. Even with images we seem to have easy access to, we often recontextualize them in the light of conversations or of other images. An image that looks peaceful and calm can be turned into

being threatening and disturbing by the presence of a subsequent image that seems to show 'what happened next'. Of course, photographic images can now be manipulated digitally to recontextualize them too.

Some images exert a particular fascination for us, they hold our attention and often fix that attention on the person or object photographed. They are particularly vivid images that seem to give over a presence that is beyond the mere image on paper or screen. They display an iconicity that fixes strata of knowledge and belief in a spectacular fashion. Unusual images, exotic images, sexual images, are among the most persuasive of this type; as familiar to the medieval rhetor as the postmodern advertising executive. These images, like others of a perhaps less persuasive character, encourage the development of associated narratives. Sometimes we create these narratives for ourselves, when we look at the image and, sometimes they are created for us by other people, whether this be in conversation or by the production of a text, as in the case of the journalist. The icon with associated narratives is a very powerful image: the narratives lock the image into our conceptual array, whilst the image fixes the narratives in a form that holds deep in our memory.

Because photographs, whatever their origin, whether from a still video camera or an old plate camera, whether simply mediated, as a Polaroid, or deeply mediated, as in the digitally constructed image, are persuasive, hold our attention, remind us of family members, encourage us to fantasize, they can be used in a wide range of situations. We use photographs to remind ourselves of things we have lived through and places we have been. We allow ourselves to be informed by the photojournalists and persuaded by the advertisers. We collect photographs of family and family events in albums to be passed around and discussed and to remind ourselves of how things seemed before. We become enraptured by the image of the desired. We put images in sequence in film and television that allow all this and both the perceived passing of time and the perceived movement of the image, and marry those to the articulation of sound, whether voice, location or music. We know the significance and the power of this linear structuring of images.

Multimedia and knowledge structures

Multimedia opens the door to capitalising on this history and extending the conceptual range and grasp of the image by encouraging the intersecting of multiple paths, the revisiting of desired locations and the restructuring of the whole to suit the approach which we desire. Of course the pull of the narrative is still very strong and given its metaphorical connection with the journey of life, unlikely to lose its grip. And other metaphors hold traditional places in our

conceptualization. Knowledge was often structured on the tree metaphor in medieval times; this natural device has been developed more recently into the metaphor of the rhizome. Architectural devices were used to articulate knowledge; then printed text itself focused the special form of knowledge that led to the growth of science. The teacher, the preacher and the presenter act to move us through a domain of knowledge and this metaphor is embedded in the articulation of many non-narrative texts and their embodiment in film and television. In these traditional means of representation the range of the knowledge domain tends to be fixed in the representation (although clearly not fixed outside of this representation). In multimedia the range can be fixed or it can lead directly into an open-ended situation; a situation more akin to sitting with a telephone and a directory of the world's telephone numbers.

Too much choice without guidance leads to inaction. Multimedia can allow the interrogation of distant databases, whether of images, texts or sounds or the exploration of virtual realities. It can provide an agent that can be instructed to open only those doors that are commensurate with an expressed interest, like being told where the books on philosophy are in the library. Multimedia is based around our interaction and our choices. It can enable us to personalize the way in which knowledge is represented to us. Although it has many similarities to television, it is fundamentally different. We are only just coming to terms with the grammar of television and it continues to develop apace. We have not really yet started to understand the grammar of multimedia. We know that it is exciting, demanding and dependent upon emerging technologies. We have just begun to use it.

Producing multimedia

If we are to produce multimedia then we have to recognize that we are involved with the business of knowledge representation. All cultural products are bound up with knowledge representation, but those that have been with us for a long time, have their structures and methodologies historically determined. This is not to say that they don't vary, they do; but they do so relative to their historical trajectories. Because multimedia potentially encompasses so much, we must start with a means of analyzing the knowledge we wish to represent. This is best done by conceptual mapping. We have to first map out the knowledge in order to be able to represent it. We can't just blurt out what we wish to say and hope it will connect, we can't just press the shutter release and move on, we have to articulate our understanding of the knowledge in a form that can then be translated and transformed into a representation of that knowledge.

In the early 1970s conceptual mapping of this sort was at the heart of the first Indexes produced by Art and Language; they are models of what is required for multimedia. They were concerned with unpacking particular articulations of concepts, particular texts, and representing them and their contextualizing modalities in a map-like form, from which clusters of agreement, concurrence, disagreement and commonly held conceptualizations could be 'read'. In multimedia we can see this as a way of representing clusters of knowledge on a matrix; of course there was then and there is now the added complication, that the matrix never remains static. Sometimes in order to produce an actual product we have to ignore this; but we know that a dynamic matrix or matrices are the natural starting point for a real representation of knowledge. It doesn't keep still, why should its representation. Of course it's not hard to see that structures can be provided to hang certain sorts of knowledge on. Think of the tree metaphor above and we can easily see how knowledge that already uses this metaphor can be structured and thus represented in tree-like structures. A multimedia family tree with photographs of family members, voice recording of one family member talking about another, video of others, can be easily understood and could be the way family albums will be in the future. You can wander around the family and structure its articulation of itself and develop it yourself, by putting in new multimedia events. This is a simple example of one small way in which multimedia will start to impact on our lives. Its real impact will be large and pervasive. It will become part of our daily lives at home, at school and at work.

Conclusion

Multimedia is a powerful means of representation that will reshape our understanding of the world. It will tend to become transparent. We will not notice that it is a means of representation. It will appear in many forms and we will use it in many ways. For the producers of multimedia there is a lot to be learnt in terms of methodology and orchestration. Knowledge design is a significant part of the future. Knowledge fluidity and mobility will characterize our understanding. The dominance of the text will slide. We will personalize our interaction with the new representations. New cultural product will emerge; the multimedia opera will become a significant artifact alongside the book and the film.

Keith Piper

fortr
europ

Keith Piper is a mixed-media
artist based in London. Born
in Malta in 1960, he studied
Fine Art at Trent Polytechnic
and Environmental Media at
the RCA. He has recently
been experimenting with the
various applications of
computer and videographic
technologies in the multimedia
visual arts environment.

Thus, Fortress Europe is becoming a reality.
The situation is primarily identified as a
security problem, although it is also
secondarily acknowledged as an economic
problem. Europe's historic frontier of
confrontation with the world of Islam is
being reactivated. The question of Europe
and the south, Africa, Asia and Latin
America, is acquiring new dimensions.

Fictions of Europe

ess
ne tagging the other

New times/new technologies

The October 1988 issue of *Marxism Today* carried on its cover a stratified landscape of flat, vivid colours arranged above a line of text which boldly proclaimed the imminent arrival of 'New Times'. From the editorial of the same issue:

At the heart of New Times is the shift from the old, mass-production Fordist economy to a new, more flexible, post-Fordist order based on computers, information technology and robotics. But New Times are much more than economic change. Our world is being remade. Mass production, the mass consumer, the big city, big-brother state, the sprawling housing estate, and the nation-state are in decline: flexibility, diversity, differentiation, mobility, communication, decentralisation and internationalisation are in the ascendant.

In retrospect it has become difficult to identify the sources of such optimism (especially from the vantage point of the political Left in the grip of the then, ninth year of Thatcherism), which could lead to it looking forward to this decade with an almost Utopian fervour. Whilst in a sense such optimism must be severely tempered by the growing recognition of unfolding catastrophe, from global warming to the absolute reassertion of Western hegemony over the planet in the wake of the Gulf War, we can still in fact recognize that these are indeed 'New Times'.

However, far from the liberating, diversifying, flexibility provided by the 'New Technologies', we seem to be increasingly confronted with what is almost becoming reminiscent of the post-modern, cinematic genre known as 'tech-noir'.

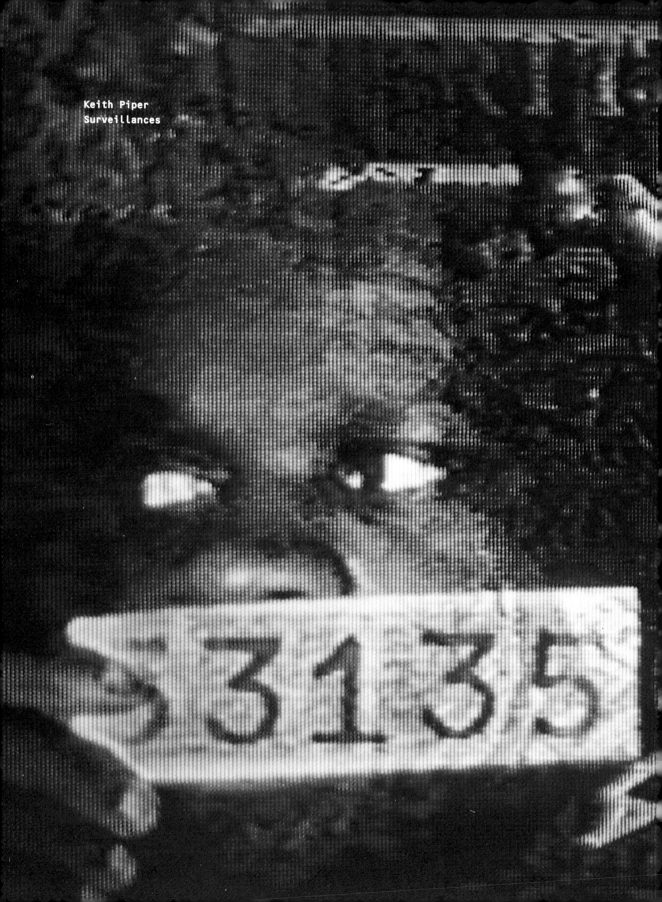

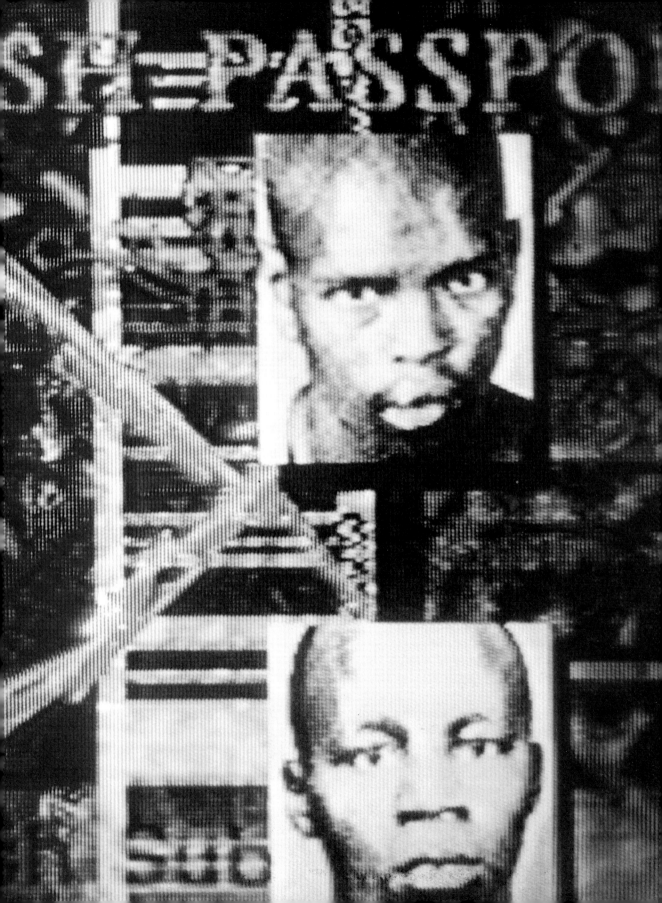

Within our new consciousness, places such as the 'city' become less about diversity and enablement, and more about terror, confinement, surveillance and chaos. Mass communication becomes more and more the sole preserve of the multinational corporation. Even the liberating silicon chip, cited so optimistically in the past as the precursor of a new age of leisure, has instead merely accelerated the frantic pace at which we are compelled to negotiate our ways around our environment. It creates for us, even in our rare 'off peak' moments, less of a recreational bonanza, more of the narcotic effect of constant and conspicuous consumption.

This is, of course, a one-sided view. In line with the technological project of the New Times, it becomes important that we recognize, especially from the point of view of those of us involved in cultural production, how new computer technologies have enabled access to areas of practice which in the past have remained barred to all but the economically franchised. It is now possible to walk into colleges, community resource centres, and even the domestic environments of some of the more obsessive technophiliac's amongst us, and to encounter computer-based technologies capable of preparing camera-ready artwork for the most graphically complex of publications, music to professional standards, and video-graphics of approaching broadcast resolution. What remains clear however, is that whilst there has been this democratization of the means of hi-tech cultural production, the mechanics of distribution, access to public broadcast and mass publication still remain the closely guarded domain of the franchised. Power in this new age, is becoming much less about control over the points at which information or cultural products are created, and much more over the channels through which information is transferred, accumulated and disseminated.

Within this new equation of franchisement to, and disenfranchisement from these informational networks, the computer has become a key strategic player. The term 'hyperspace' has recently entered techno-speak in recognition of that whole other universe which lies on the other side of the computer terminal. It is a universe into which information can be entered, translated into a binary coded stream of switching electronic pulses, and then stored, transferred, accumulated, accessed and manipulated with almost total disregard for the strictures of physical time and space.

It is however our growing realization that as individuals, we are forced to interact with this rapidly expanding universe of hyperspace with increasing and, in many cases, involuntary regularity. It is becoming clear that as we negotiate our way around the contemporary environment we are constantly being compelled to deposit clues, traces of our passing, into the void of hyperspace. Every time that we use 'plastic money', punch in a PIN number, pass through turnstiles or electric eyes, pay (or fail to pay) a bill, make a telephone call, come under the gaze of a surveillance camera, fill out a questionnaire or file an application, a record of our activity is deposited into the binary encoded constellation of hyperspace.

This in and of itself should not represent a reason to be fearful. It is only when we begin to consider the question of access to the information floating around in hyperspace in light of two of the new 'buzzwords' in computing that a whole set of other implications are generated.

The first term, 'Networking' appears innocuous enough. A glance through the April 1991 issue of *Computer Shopper* tells us that:

The concept is blissfully simple – to be able to take the resources of one computer, and share them with those of another.

Within a Network it becomes possible for the instantaneous transfer of information to take place between any number of computers. The integration of computer technologies and telecommunications means that this transfer can take place between computers on opposite sides of the globe with the same ease as between computers on opposite sides of the same room. Hyperspace thereby becomes trans-national, for the information located within it, distance and physical location become an irrelevance.

The second term, 'Multimedia' represents a technically more complex area with vast implications for the future of computing. Once again, from *Computer Shopper* we read:

A true multimedia machine would be able to store and retrieve text, video and data without making any strong hardware distinctions between the three types of information. That is, a single device, such as a hard or optical disk, would be able to store all of the data.

We are looking at a technology capable of translating information from a variety of physical sources into computer-readable binary code and depositing it into hyperspace. We are no longer limited to laboriously punching out our messages to the computer on a keyboard. Within the multimedia environment the computer becomes capable of translating; for instance, the fall of light upon the CCD of a video camera, or the pressure of sound waves upon the diaphragm of a microphone. It will be able to read a palm-print and identify a voice pattern. A rapidly expanding range of actual physical phenomena have their binary encoded equivalent, and in this brave new world, not only text, but records of visual phenomena and sound can be entered into and accessed from hyperspace. It is therefore becoming possible for records, not only of an individual's personal history, financial details, racial origin, gender, occupation, political or religious affiliations, sexual orientation, criminal record, but also visual representations of appearance and audio information containing voice patterns, can be accumulated, processed and transferred around a local, national or global informational network.

However, these developments take on an even more sinister range of implications when we consider once again the question of who is allowed, and who is denied access to the new informational reservoirs. As we have already identified, within the modern world, enfranchisement into certain informational networks has become the guarded preserve of particular powerful state and economic interest groups. It is a power which holds particular implications in regard to policing, and the new technologies of surveillance and social control. In the book *Techno Cop* by the BSSRS Technology of Political Control Group, we read:

The Police National Computer (PNC) provides a central data base for police throughout the whole country. It is housed in a specially fortified building in Hendon in North London. The enormous data-handling capacity of the PNC's computers enables the police to store information on over 5 million people in various categories of interest.

It would not stretch credibility too far to speculate around the extent to which these 'categories of interest' extend beyond a simple concern with the criminal into areas around political affiliation and activities. The implications which lurk at the crossover point of policing, new technologies, and the integration, especially of photographic and visual information into computer files, reopens and reinforces a whole body of discourse around photography and the exercise of the power to criminalize and to name the 'other'. In David Green's essay; 'On Foucault: Disciplinary power and photography' in *Camerawork*, summer 1985, no23, we read:

The employment of photography in the fields of anthropology, medicine and criminology in particular, draws together a whole series of discursive operations levelled at the body and organized along the axes of race, class or gender. Subject to the gaze of the camera the body became the object of the closest scrutiny, its surface continually examined for the signs of innate physical, mental and moral inferiority.

The ongoing power of the photographic image to fix and categorize, to map out and identify those elements which denote difference, is expanded and amplified within the integration of photography with new computer technologies. The implications of this integration within the arena of policing are far reaching. It is however within the area of policing which concerns itself with the identification of the racial outsider and its placement within the construction of a new 'European identity' which concerns us here.

New Europe/New Europeans

What is of interest is the body of assumptions and aspirations which forms a back-drop to the political and economic passage towards what has come to be known as the 'Single European Market', which will form a principal precursor to a new age of proposed European unity. As a continent, Europe has historically been racked by conflicts around the drives to corral various nation states into a unified whole. But, in the contemporary world, compressed between the economic monoliths of Japan on the one hand and the USA on the other, in a pragmatic endeavour to compete, European unity is once again placed high on the agenda.

Once on that agenda however, the concept of 'Europeaness', begins to raise a whole set of

particular difficulties against the backdrop of the modern world. In Jan Nederveen Pieterse's essay *Fictions of Europe*, we encounter a very particular notion of 'Europeaness' quoted from a Dutch Ambassador, Mr M. Mourik:

What determines and characterizes European culture? …Europe is formed by the community of nations which are largely characterized by the inherited civilisation whose most important sources are: the Judaeo-Christian religion, the Greek-Hellenistic idea in the fields of government, philosophy, arts and science, and finally, the Roman views concerning law.

The theme of 'Europeaness' as a phenomenon bounded from within by a range of noble commonalities is further exemplified by the German sociologist Otto Jacobi in a quote from his essay *Politics of 1992* he writes:

At the risk of grossly oversimplifying, might I dare list a few examples of European virtue and progressiveness? Rationalism, science, technology and industrial capitalism is one group of European inventions; others include enlightenment, humanism, secularism, tolerance, democracy and the social welfare state.

Beyond its innate racism and Eurocentricity, what emerges from the above quote is the sense that 'Europeaness' is, and has always been, bound together by elements internal to itself; by the recognition of a given set of cultural determinates which give it definition. A far less flattering, but perhaps more accurate, view is provided by Scott L. Malcomson in his article *Heart of Whiteness*:

Pan-European ethnicity was forged, initially, in violent opposition to nonwhites. Mongols, Turks, Moors…and later in opposition to Africans, Asians, and New World indigenes (with Jews providing a handy internal Eastern Question).

This view is echoed by British journalists

Nicholas Colchester and David Buchan who in their book *Europower* point out that:

Catholic Christendom imbued Europe with a feeling of unity until the end of the Middle Ages. The earliest pan-European sentiment arose out of reaction to a common enemy with an alien religion – the Muslim, Ottoman Empire.

It is the point of convergence between those ideologies which see Europe both as the well-head of civilization and enlightenment, and as custodian of that civilization and enlightenment against the threat posed from without, which forms a common theme to the development of European xenophobia and racism. When Margaret Thatcher in her 'Swamping speech' expressed her anxiety about the threat which she believed a black presence constituted to 'The British character' which to her mind had 'done so much for democracy…throughout the world', she (maybe unintentionally) echoed a Pan-European theme which sees Europe in the words of Jan Nederveen Pieterse as:

The land of liberty, as against Asia, the land of despotism and oppression – in a word, oriental despotism and occidental liberty…This is the most prominent rhetoric of difference between Europe and non-European worlds.

It is however plain from the histories of European imperialist expansion that far from being forged under threat from without, it was in fact European cultural imperialism which sought to dislocate and undermine other civilizations across the globe. Much has been said about the centrality of imperialist expansion and colonization to the development of European Capitalism and industrialization. The fact is that even in the post-war era of decolonization it remained central to the interests of the colonizing power to retain those links which kept the ex-colony at their economic disposal. This was not only in terms of ensuring the continued flow of raw materials. In the aftermath of the Second World War it became increasingly about the need to import units of manual labour. In a pattern followed across the continent, workers migrated both from the southern, eastern, and in the case of the Republic of Ireland, western fringes of Europe, as well as from the colonies and ex-colonies, to service the labour needs of the European industrial heartlands of West Germany, France, Switzerland, Holland and the United Kingdom. In fact, by the early 1970s, *Fortune Magazine* was to declare that:

Migrant workers now appear indispensable to Europe's economy. One-seventh of all manual workers in Germany and the UK had come as immigrants, and in France, Belgium and Switzerland, a quarter of the industrial workforce was immigrant.

Even as these workers settled, fundamental shifts became apparent which threw the heavy industrial base of many European economies into deep recession. The now internalized pools of surplus non-white labour sharpened the need in the eyes of individual European governments both to ensure that these minorities grew no larger, through immigration control; and to control their rights to expression, representation and freedom of movement through the exercise of the mechanics of policing and state control.

This can be seen to be a response to the collective phobia currently crowding European collective psyche, which sees a vast tide of dark-skinned peoples potentially flooding Europe in search of relief from the poverty and instability of the so-called 'Third World'. In this context, the nations of Southern Europe: Italy, Spain and Portugal have come to be seen as the new frontier, whilst in the wake of the end of the 'Cold War', the West's perceived age-old enemy, that of Fundamentalist Islam haunts it from the East.

Once again, from the essay *Fictions of Europe* we read:

Thus, Fortress Europe is becoming a reality. The situation is primarily identified as a security problem, although it is also, secondarily acknowledged as an economic problem. Europe's historic frontier of confrontation with the world of Islam is being reactivated. The question of Europe and the south, Africa, Asia and Latin America, is acquiring new dimensions.

Or to summarize, as A. Sivanandan points out in the editorial of the January-March issue of *Race and Class*:

The problem with an open Europe...is how to close it...against immigrants and refugees from the third world.

Tagging the other

On 1st January 1993 the internal borders of the twelve countries in the European Community (EC) will officially come down, allowing for the free movement of goods, services, capital and (some) people.

Tony Bunyan, *Towards an Authoritarian European State*

The meeting point between the theme of the role of new information technologies within the mechanics of state control and surveillance, and the European phobia of the non-European 'other', is brought into sharp focus within the run-up to a united Europe. Whilst our attention has been drawn to the traumas around the establishment of the various quasi-democratic superstructures of the new European super-state; central banks, Councils of Ministers, etc., there has been another agenda, only now coming to light, what Tony Bunyan describes as the 'other' Europe:

On the other hand, behind these formal institutions lurks the beginning of another state apparatus, made up of ad hoc and secretive bodies and separate inter-governmental arrangements...The main mechanism of the 'other' Europe is the Trevi group of ministers (1976), the Ad Hoc Group on Immigration (1986) and the Schengen Accord (1985 and 1990).

The Trevi group of ministers was set up at the behest of the British Government in 1976. Its name exists as an acronym for 'terrorism, radicalism, extremism and violence', and one of its first actions was to establish a liaison network between the internal police and security agencies of individual member states through the creation of a 'secure communications system'. At the time of the Single European Act of 1987, however, the Trevi group had expanded its remit from its initial focus which centred on terrorism, to embrace all the 'policing and security aspects of free movement'. This included immigration, visas, asylum seekers and boarder controls. The logic behind this was that the principle of free movement set out in the Act presumed that all those living and working inside the EC would be legitimate residents and not illegal immigrants or 'undesirables'.

Beyond this the Trevi group does not see its role as merely 'hardening the shell' of fortress Europe against 'undesirables' from without. Central to its mandate is the view that the 'disease' of undesirable and essentially 'anti-Euorpean' elements had already grown inside the 'soft centre' of Europe. All of the mechanics of surveillance and control would have to therefore operate not only at the borders of Europe, or even individual European nations, but would also be 'internalized'. The eye of high tech scrutiny would therefore systematically be cast across those communities of settled 'immigrants' in order to identify and seek out what 'Working Group 1' of Trevi describes as 'undesirable aliens from third world countries'. This whole system of

surveillance and control will operate through a network of computers, including the New Police National Computer based in Hendon, and centring on the European security computers based in Wiesbaden, Germany.

The Ad Hoc Group on Immigration was set up in 1986 with the aim of policing what it saw as 'abuses of the asylum process'. It is the group responsible for the notorious legislation of April 1987, which fines airlines for bringing undocumented asylum seekers into any European country. It becomes clear that the new technologies can seek documentation and categorisation from the point of entry or departure.

The Schengen Agreement exists as a mechanism for the 'harmonisation' of the policy around the issuing of visas across the EC, and strict rules as to the identification and classification of 'Undesirables'. An 'Undesirable' in this context is defined as 'someone from a non-member state who has been or who is likely to be refused entry to a member state', and through its very broadness operates to restrict the possibility of black and third-world peoples from entering Europe.

Like the Trevi group, the Schengen Agreement is also backed up and serviced by a powerful computerized intelligence and information system, called the 'Schengen Information System' which has recently been moved to Strasbourg in France.

The net effect of these developments has been to cast an ever more complex and all pervasive net of scrutiny over the inhabitants of what will become the New Europe. In terms of the internal non-European populations of individual European Nations, this surveillance will become even more pervasive in its efforts to weed out 'those who do not belong' and thereby effectively criminalize entire communities. In a sense the revealing of a new agenda of 'Euro-Racism', running concurrent with the demands of black populations around the continent for full enfranchisement, must over the next decade begin to result in the development of a 'black European consciousness' which will seek to express the connections between Turks in Germany, West Africans in Paris, Dutch West Indians in Amsterdam, and Bengalis in East London in a common consciousness of migration and struggle.

In the meantime, from a personal point of view, it is becoming increasingly difficult for me, as a British person of African/West Indian origin, to pass through any European immigration point (especially Heathrow Airport) unchallenged. The mechanics of surveillance and control are already revealing themselves.

David Green, 'On Foucault, Disciplinary Power and Photography', *Camerawork*, Summer 1985 no23

'Net Results', 'Multimedia, Down to Earth', *Computer Shopper*, April 1991

'New Times', *Marxism Today*, October 1988

'Europe: variations on a theme of racism', *Race and Class*, January-March 1991

Scott L. Malcomson, 'Heart of Whiteness', *Voice Literary Supplement*, *Village Voice*, March 1991

takin
back to m

talking to esther parada

The computer has enormously facilitated this process of fragmentation, enlargement, and layering of images. I like to think of it as an electronic loom strung with a matrix image, into which I can weave other material – in harmony, syncopation, or raucous counterpoint, to mix metaphors. I hope to create an equivalent to Guatemalan textiles, in which elaborate embroidery plays against the woven pattern of the cloth.

Esther Parada

Trisha Ziff curates exhibitions and writes about photography. Today she lives in Los Angeles and Mexico City. In 1989 she edited the book *Still War: images from the North of Ireland* with an Arts Council Grant. In 1990 she was commissioned by the Impressions Gallery to curate 'Between Worlds – Contemporary Mexican Photography', an exhibition and book. At present she is writing for different journals on photography and new technology and is curating an exhibition on the history of photography within the Chicano community in Southern California.

Esther Parada is Professor of Photography, School of Art and Design, University of Illinois at Chicago.

new ideas
old world
tor méndez caratini and pedro meyer

Article compiled on Macintosh SE with Radius screen, using Microsoft Word and Fullwrite Professional 4.0. Text sent by fax, Federal Express and Applelink from Los Angeles to London, Chicago, Illinois, San Juan, Puerto Rico and Mexico City. The texts were taken from recorded telephone calls, faxed letters, transcripts using a Canon video camera, and transcripts using an Olympus microcassette recorder and an Aiwa cassette tape recorder.

The artist picks up the message of cultural and technological challenge decades before its transforming impact occurs.

Marshall McLuhan[1]

The prevailing attitude I have experienced amongst the photographic community in relation to new technology is one of suspicion, fear of change and concern about the erosion of the individual's control over the use of images. Consequently, technological advancements are dismissed by many people, mainly in the spirit of 'wishing them away'.

Is it not better to understand the implications of change (and resolve these questions of copyright in new ways) than to disregard everything?

Ultimately what is important is what we have to say, and finding the best means of communicating our ideas. Photographers who choose to overlook the technological revolution will eventually become caretakers of a dying craft, where

Pedro Meyer
Jonathan & Cubist Fruit

This 'photograph' started out with a slow
scanning black-and-white video image of
Jonathan, a friend of mine. After this stage,
the background images were created by scan-
ning into the computer a video colour image
of real fruits. All of the images were then
manipulated with the aid of image processing
software and arranged according to my visual
needs. The final composition was then printed
on a computer-driven ink jet printer on to
the classic 'Arches' paper used extensively
in the art world.

The picture is for practical purposes a
nonexistent reality, obviously nothing of what
you see was actually the way you see it here,
it's all fantasy, even though it's based on
'real' factual sources: a person, and some
fruits. In keeping with the process of
exploring new technologies, this image is
made up solely of electronic signals, none
of the traditional photographic materials
(film, paper, photo camera, chemicals, etc.)
was used. From start to finish this image is
the outcome of an electronic composition.

I have always been puzzled how the photo-
graphic image conveys credibility to the
most uncanny stories. Like in so many other
parts of the world, in Mexico City we also
have those surprisingly popular tabloids
which publish all sorts of crimes and bizarre
stories, such as three-headed children, or
four-legged ones, which supposedly were born
'the week before'. I thought to myself how easy
it would be to create proof for such fictitious
stories with the aid of all these new tools
and the credibility that a photograph tradi-
tionally conveys, and how this could be the
source for an incredible hoax on all those
people less well informed about the potential
to generate such aberrant stories. So this
'photograph' is dedicated to all those who
still believe, and to Caravaggio as well. May
the viewers beware!

process and form will become more significant than content. This in not a question of either/or.

I had long conversations with Esther Parada, Hector Méndez Caratini and Pedro Meyer: three photographers who have been working with both 'the grain' and 'the pixel'. They have never exhibited together, although they have many things in common; their perception is a complex of intricate personal journeys which criss-cross. They come from Chicago, Illinois; San Juan, Puerto Rico; and Mexico City. They all began working as photographers within the documentary tradition, and today are working with computers as well.

It is impossible to live in the Americas and not be touched in some way by the US's cultural dominance. All three acknowledge in their art the influence of the United States. Through their personal histories and cultures, they look out across the American continent, witness change, and comment on what they see.

Much of Esther Parada's work is based on her own experiences when she was living in Bolivia (working for the Peace Corps from 1964-6). She continues to think about the relationship between North and South, and examines US foreign policy toward Central and South America.

As a woman I have a country; as a woman I cannot divest myself of that country merely by condemning its government, or by saying three times 'As a woman my country is the whole world.' …I need to understand how a place on the map is also a place in history within which…I am created and trying to create.

Adrienne Rich[2]

Hector Méndez Caratini delves back into the history of the Mayan of Puerto Rico, and records what is left today of the island's indigenous culture before it is eclipsed by the US.

Pedro Meyer, from his Mexican perspective, looks north towards the largest border between the First and Third world. He states:

the entire world is effected by the US. The fact that most cultures in the world are so influenced by what goes on there needs to be inspected closely and commented on.[3]

These are complex journeys: they embrace change; they confront conflict and dominance; they investigate language and culture.

When we (in a technically sophisticated society) think of electronic media and digitized images, we associate these technologies with 'our' world. We make assumptions that artist/photographers working in this field will be from our own cultures. Here we are presented with another perspective. As the 500th Anniversary of the 'discovery' of the Americas approaches, perhaps it is fitting that these artists are bringing their ideas from the new world back to the 'old world' through new technologies .

Esther Parada
An electronic loom

Trisha Ziff

I have never met Esther Parada. However, over a period of months we have written, faxed and Applelinked each other, and have talked by telephone. I have seen her work in journals, catalogues and in the publications she has produced independently.

The following texts are extracts from our letters and conversations about her work; also included are edited transcripts from a taped telephone interview. Each section is taken from a variety of sources, coming together like fragments of a jigsaw to form a new image. The possibilities are endless – adding, editing, cutting, pasting, refining.

During our correspondence Esther sent me quotations by several writers who she felt were relevant to her own ideas of the working process. Included was the following text by James Clifford. The spirit of his words regarding the 'utopia of plural authorship' became a significant element in our discourse; he qualifies this Utopia because:

First, the few recent experiments with multiple-author works appear to require as an instigating force, the research interest of an ethnographer who in the end assumes an executive, editorial position. The authoritative stance of 'giving voice' to the other is not fully transcended. Second, the very idea of plural authorship challenges a deep Western identification of any text's order with the intention of a single author...nonetheless, there are signs of movement in this domain. Anthropologists will increasingly have to share their texts, and sometimes their title pages, with those indigenous collaborators for whom the term 'informants' is no longer adequate, if it ever was.[4]

Esther Parada's work is a combination of the image and the written word: a collage. In her recent work the content is constructed and manipulated by computer. The foundations for her work vary in scale – a letter, a framed image, a poster, a book, a screen or a gallery wall. Many of the images she uses are private, taken from the family album, experiences from her own life; but her statements are public.

Esther Parada

My life and the lives of those dear to me have been profoundly and intimately affected by public images – by the *invisibility* or *negative visibility* of cultural difference.

I grew up dark and Semitic in Grand Rapids, Michigan, in a world of fair-haired children; I was raised Jewish in a city heavily Dutch Reformed. Yet my sense of displacement was not a question of numbers so much as the non-representation of my identity in books, magazines, television,

etc. – my virtual *non-existence* in any public forum at this time (the 1940s and 1950s). No wonder each December I begged my mother to buy us a Christmas tree.[5]

Trisha Ziff

…Today, I felt invisible. While I was out shopping at the supermarket, an announcement suddenly replaced the usual Muzac declaring that ten minutes ago the US Air Force had begun bombing Baghdad.

I immediately returned home to watch CNN. In this age of instant communication, I sat watching what in effect was a radio. The image on the TV was a map of downtown Baghdad which remained on the screen like the test card. It held my attention. I listened intently to three men in a hotel room report on a bombardment which I could hear in the background, and comprehend only through their adrenalin-filled voices. I had first heard CNN in my hotel bedrooms while I was travelling through Europe. Now, the news is being made from a hotel bedroom in Baghdad. A strange reversal.

I cannot believe what is happening in the world. There seems to be limited visibility for those of us here who do not wish to form part of this 'New World Order'. We are invisible.

Last weekend we went to MacWorld.[6] There was a demonstration of janitors outside the conference centre. Their songs and slogans were shut out during John Sculley's keynote speech.[7] They were protesting against their working conditions, walking round and round in a circle singing songs in Spanish, and leafleting MacWorld visitors. These workers have no health insurance, and were demanding an increased wage (at the moment they earn $5 an hour). I thought about these people's lives in relation to our consumption of new technology…On those wages, how could these workers ever think about owning the products their labour indirectly helped to create?

New technology/traditional labour relations…

It reminded me of your work *Circle of Poison*,[8] where on the papiermaché mask you quote:

…every minute/someone in the underdeveloped countries is poisoned by pesticides./But we are victims too./Drinking a morning coffee/or enjoying a luncheon salad/the American consumer is eating pesticides/banned or restricted in the US/but legally shipped to the Third World.[9]

Inside, the huge exhibition hall was like a high-tech beehive. Without daylight, there was no sense of time, nor talk of war. Life just continued. 'Most computer development was originally made for military purposes, designed by men,' Bob Stein of the Voyager Company[10] told me. 'There are few women programmers; perhaps that's why computers are so good at Nintendo games – one of the things they do best is hit a target.' Smart weapons are bombs with computer brains. The first computer war begins. These smart weapons, we are told, will save lives.

Whose lives? I ask.

I have seen many television reports on the war using language from football and Nintendo. The references are not to war itself. Perhaps these soldiers and pilots will be so conditioned to the idea of the 'game' that when they come to do 'the real thing', it will be just another game…

Who is the winner?

I sat down to write to you about our work together, and I cannot do this without describing my thoughts and feelings as the evening progresses. After all, if we were together we would probably be watching TV.[11]

My most vivid image of the surreality of it all was Thursday night at the nursing home in Chicago where my mother has lived for the last two years. She is almost totally incapacitated with Alzheimer's disease, having lost all speech, much of her movement and vision…

Esther Parada

Sad to say she is part of a community of many similarly impaired elderly women, who spend their days slumped in wheelchairs in the common dining room while a giant TV drones continuously behind them. Usually a carefully coiffed version of the *Evening News*,[12] followed by the brittle gaiety of *Wheel of Fortune*, forms the backdrop for their dinner hour. But, when I arrived last Thursday night, the poised anchor people on the screen had been replaced with groping masked creatures trailing microphones…You must have seen them too. Meanwhile in front of the TV, among the nodding residents, a ninety-year-old woman, frail but still able to walk, wandered confused and mournful, questioning each of us, 'Do you know who stole my box of Kleenex?'[13]

When I read your private letters, or I look at the photographs of your father and your extended family in *Memory Warp*[14] and *Past Recovery*,[15] I am aware that I am being invited to share your private experiences. Acknowledging 'the personal' is characteristic of feminist art. In a subtle way, I feel you are validating all our experiences as being worthy of reflection, through giving us the opportunity of observing aspects of your life. Looking at your work is not voyeuristic; you encourage the viewer to participate. Similarly, you have transformed this article by your openness into a collage of our ideas. Lucy Lippard has suggested that collage is a:

peculiarly female medium – not only because it provides a way of knitting the fragments of our lives together, but also because it leaves nothing out; it allows…all levels to confront each other, without any one overpowering the other.[16]

Speaking of the separation of personal and public – I feel on the one hand, so filled with the richness and potency of my immediate personal

life; and so sickened by reports (and the way of reporting) on the Gulf. Yes, in one sense there is an enormous gap between private and public, between individual tenderness and government atrocity. But I don't really make that separation.[17]

Trisha Ziff *Memory Warp* and *Past Recovery* draw on personal images of your family. When you showed the work to your mother, or other family members, how did they respond?

Esther Parada **Part of the connection between personal and public that emerges in my work is an obsession with perception, or more specifically, with whatever operates to constrict perception, whether in the private or political realms. I think of *Past Recovery* as meaning 'beyond recovery', as well as recovering the past; the overlaid photographs are (literally and metaphorically) the filter that keeps one from seeing what's underneath. I grew up with a 'cold war' situation within our family, and came to be acutely aware of my mother's role as filter or censor, both because of her concealment or denial of certain images and information; and because she was more communicative than my father, and talked more about her relatives.**

…In 1980 when I took my mother to see *Memory Warp*, she was absolutely silent. Although she had mellowed since my father died, it was clear that giving him that attention and space bothered her. There's one other story that indicates her continuing anger toward him – expressed toward a representation of him.

For many years she was deeply concerned about environmental waste and pollution, rejecting use of any chemical sprays around her home or property in rural Michigan, and fastidiously separating garbage from other waste (so it could be composted). However, in the last year or two before her illness became acute, she was forgetful and I wasn't surprised to find occasional paper scraps in the compost pot when I visited. But when I emptied the pot during her last winter in Michigan, I was stunned to find a torn-up photo at the bottom of a ripe heap of garbage. I washed it off and pieced it together: it was a close-up shot of her with my dad. He died in 1973 and this was 1988! It was like uncovering a voodoo ritual. So yes, I've become fascinated with photos, as the locus of what's visible or admissable in family history…or national history.[18]

Your work crosses many boundaries. Personal work in the public domain. Woman's art made with computers. Private snapshots juxtaposed with public images…

I think you're referring partly to the fact that the computer, as 'high-tech' or 'new-tech', is associated in this culture with the masculine.

However, for me working with a computer is not about mechanical or technical aptitude – although I do think that anyone using a computer as a tool needs access to good technical support, and I've been very lucky to have this in a close friend. But in general, I see computer facility as having to do with language skill – learning to use the Macintosh was like learning to speak Spanish, and it's an ongoing process. If I spend enough time with the 'grammar' of a particular programme and use it often in visual 'conversation', then I become fluent with it. Another analogy that's strong for me is that of an electronic loom, maybe because I spent so much time in the early 1970s creating macramé hangings: working with the computer is like working with fibres, the process of knotting strings to form a pattern feels like the clustering of pixels to form an image...[19]

Tell us more about this process of weaving.

Actually I understand that the modern computer developed, at least in part, from the punched cards that were used in the weaving industry. Also there is a clear continuity between what I'm doing now on the computer, and the photographic manipulation I've done for many years in the darkroom using half-tone and mezzotint screens – photo-mechanical ways of creating the illusion of tone. Yet another connection is the musical idea of theme and variations – what I call visual jazz. To what extent can you still recognize a tune buried in ornament? How far can you elaborate a form and still detect it? How big a gap can the viewer jump in terms of completing a visual Gestalt? A related question is how much information – density of images or text – can a work contain before it becomes chaotic? The computer has enormously facilitated this process of fragmentation, enlargement, and layering of images. I like to think of it as an electronic loom strung with a matrix image, into which I can weave other material – in harmony, syncopation, or raucous counterpoint, to mix metaphors. I hope to create an equivalent to Guatemalan textiles, in which elaborate embroidery plays against the woven pattern of the cloth.

In *The Monroe Doctrine: Theme and Variations* (Part One)[20] I want this process to simulate or parallel the relationship between public and private, historical and contemporary events. The viewer becomes absorbed with the micro-level, the details of the image, while the matrix or overall image may be unreadable – at least at close range – because of the abstraction of the enlarged pixels . Likewise we become absorbed with the day-to-day details or 'current events' of our lives and fail to see – or are discouraged from seeing – the historical pattern of which they are a part.

Trisha Ziff The computer is an excellent medium for collage: cut – edit – copy – paste – merge, etc. With the development of image manipulation programmes, such as *Adobe Photoshop, Pixel Paint Professional* and *Digital Darkroom*, the ability to manipulate and embroider photographs has become more accessible. Gone is the notion 'the camera never lies'; of course the photograph never was objective – that was just another myth. However with the computer we create our own myths.

Soon the photograph will not have its old power. It will be weakened, emasculated. The computer's done this; I don't know what it's going to do to the world…The photograph, which for 150 years has had a special position as a picture of reality, has had a veracity that drawing or painting didn't necessarily have…We had this belief in photography, but that's about to disappear because of the computer.[21]

Esther Parada **I actually welcome this development; I'd like to think that more overt recognition and discussion of the manipulation which has always been inherent in photographic representation is healthy. Of course, people are not necessarily aware of the subtle transformations that occur, such as *The New Republic's* recent retouching of Saddam Hussein's moustache to heighten his resemblance to Hitler![22] This is one reason I'm committed to doing work where the collaged or manipulated elements – as well as the pixillated 'look' – are obvious. You could call it a Brechtian notion of subverting illusion…**

Another thing I've found fascinating about being in the computer world – and I never expected this because I had the typical woman's fear of technology – is the interaction between users and manufacturer. For example, when I first acquired a Macintosh (in 1986) I joined the Chicago Area Macintosh Users' Group. This was an enormous organization sharing information through a monthly newsletter and meetings, as well as special interest groups or 'SIGs'. I joined the graphics SIG where software developers themselves often come to demonstrate their products and get input from their users.

In the past when I had purchased photographic equipment or products, it never occurred to me that I might actually meet the inventor and give direct feedback on my experiences with the product; but that's exactly what happens at these meetings. It's empowering. You feel like you can call up these software developers – and you do call them up – and talk to an expert who says 'Yeah, we know that's a bug, and we're working on it…'[23]

Define/Defy The Frame is an 'unfolding exhibition' which I received through the mail. An A4 folder opens up, revealing two full-colour 'posters'. The envelope acts as the frame, an anchor for the work. Images and texts provide information, and

invite response from the audience.

It is my hope that you as viewers will extend these perspectives by bringing images, texts or documents from your own personal experience or professional expertise to become participants in this 'unfolding exhibition'.[24]

You invite the reader to enter a dialogue with you by publishing your address, and you explain exactly how the object was made, naming equipment, software and materials. You remove mystique, and make yourself available to others.

The reality is that although I published that information, I have never had a response. I think people are busy and not necessarily thinking along these lines. For an interactive project to work, I feel that each person has to have a vested interest in the work; it doesn't happen casually.[25]

I understand. In this text we both have a vested interest. No longer is it an article by me about you. It becomes a collaboration. You extended a similar openness in *The Monroe Doctrine* installation at the Centro Cultural de la Raza in San Diego (1988) where the process of a 'quilt' was developed.

The Monroe Doctrine was one of four installations at the Centro, which is not only a gallery, but a cultural center for Hispanics in the San Diego area. As such it has all sorts of groups involved in mural-making, dance and music classes, meetings and performances. It's a cultural focus for the Hispanic community. It's also a place of encounter for the two cultures which converge in that area – Anglo and Latino.

My proposal was that they would install the piece, and I would come out during my spring break two weeks later with my computer equipment, so that we could incorporate new information or images into the piece. Since it was mounted with map pins, allowing removal and modification of the components, I wanted to use it as a kind of focal point for responses to this power relationship between the United States and the rest of the hemisphere. I knew that there were many immigrants living in that area, and that there was a lot of sensitivity to that issue because of San Diego's border situation...

Getting back to the idea of the electronic quilt, which was the term Chuck Kleinhans[26] **used to describe this piece: I think it's a wonderful term, in that it implies popular participation. You think of quilting bees as something social, a structural framework for something done collectively – the AIDS quilt, for example, as a communal form of mourning a shared tragedy. You think of the quilt as preserving memory, the patchwork quilt as a way of salvaging scraps from the past.**

This relates back to our earlier comparison of computers with weaving, and to the function of textiles in a more general way. Among Mayan and Peruvian indigenous peoples, for example, women are the producers of these textiles and as such, they become in a manner the preservers of culture somewhat comparable to women in our culture who keep the 'family album'. But the cloth is worn; it's present on a daily basis, not just put on the shelf. Likewise, quilting represents that salvaging of history which is available for daily use. Ideally, an electronic quilt might be a cross between an epic tapestry and a bulletin board.

One of the students who worked with me in San Diego was so thrilled with the immediacy of the process; he was saying: 'Stuff that just came out in the papers today you can put in that piece!' You know, it's like 'hot off the press' and onto the press again – onto *this press*! Then I thought to myself, 'Oh no, it's topical, and artists don't *do* that...' But I was really tickled because of that quilt idea, and because I realized that maybe I *can* have it both ways: both the historical framework that I was talking about earlier, and the most recent information, so that the work has an immediate responsiveness. It makes me an instant publisher; but it does not preclude doing something that is finessed, resolved, or that has historical roots.[27]

Trisha Ziff In *Whose News? Whose Image? Whose Truth?*,[28] work made prior to your experience with the computer, you examined two perceptions of the same woman, Nora Astorga, seen as a *femme fatale* or 'Shanghai Lily' in the *New York Times* (20 March, 1984), and as a dedicated revolutionary and comrade in the book *Sandino's Daughters*.[29] I see this piece as a prelude to *Define/Defy the Frame*. Here again you juxtapose the public and personal image (or the master vs the alternative narrative). On one side of the poster we see Oliver North at the Contra Hearings, holding a slide. He represents the mainstream view, the aggressor/US foreign policy; the photograph is taken from a newspaper. On the other side of the poster is a portrait of Doña Maria Medina Pavon, an ex-housemaid in Nicaragua, who holds a family portrait. She represents the private view, the recipient/a Nicaraguan nationalist; the photograph is from your own slide, derived from your own experience in Nicaragua. In this case we are looking at two very different people, and we gain insight into their totally different relationships to the political developments in Nicaragua.

Esther Parada *Define/Defy the Frame* is the most open ended of *The Monroe Doctrine* series. In fact, it is called an 'unfolding exhibition', intended in both the literal and figurative senses of the word 'unfolding'.

I wanted to emphasize not only the difference between the two main characters (Oliver North and Maria Medina); but also the *asymmetry* of

our knowledge of them, the incredible disparity in their relative visibility to the US public. I chose the image of Oliver North from the time of the Iran-Contra hearings, when Congressional discussion revolved around whether or not he would be allowed to show his 57 slides, as symbolic of the massive attention given to extremely narrow parameters of debate in the US mainstream media.

My response to such clamor is not to suppress North or his images, but to examine them and the issues behind them – 'to define the frame'. Each time the North image appears, for example, it is retouched or modified, thus making explicit the manipulation so often covert in the media. Even more important, I want 'to defy the frame', in the sense of expanding the story, urging others to offer their images, and allowing images which construct a complex portrait, although they may confound any notion of the 'politically correct'. For example, we see Doña Maria within the now-classic genre of folk portraits, proudly holding her family photograph; but we also see her relaxed in the company of her friend, Colombian photographer Adriana Angel; and distinctly small, even forlorn, in front of a rousing poster from AMNLAE (the Nicaraguan Women's Association) on the wall of her one-room home. The poster shows a heroic figure with the slogan 'Building the New Country (in Spanish this is "patria" or literally "fatherland") We Will Make The New Woman...'[30]

We entered into this correspondence as war in the Gulf began, 'Desert Storm' might now be over, but the chaos and internal turmoil in Iraq is immense. Fewer US and British soldiers died in this war than do on the roads of the USA during the Fourth of July weekend holiday. Yet an estimated 100,000 Iraqis died. So much for smart weapons saving lives! Will the reality of the last few months surface in your new work?

Actually it's amazing to me how our dialogue on the issues of the war has resonated with images and reports from the Gulf – plus an earlier series of black-and-white photographs I took at the Vietnam Veterans' Parade in Chicago, 1986 – to produce a new series which I might call 'meditations on manliness and patriotism'. Another catalyst for this is an upcoming, interactive exhibition at the California Museum of Photography in Riverside,[31] which is based on the museum's Keystone-Mast stereograph collection. I approached this project intending to look for representations of the Americas which would reveal the roots of the US imperial relationship to the hemisphere; but I found myself drawn especially to the images of our military ventures, the disquieting parallels between earlier periods and the present. For instance, the stereographs

from the series 'Mexican Uprising' (1917) proudly focus on the US military equipment employed in pursuit of the 'hostile Villistas'; or images from the Spanish-American War celebrate the welcome of General Fitzhugh Lee, entering Havana (Cuba) at the head of his army, 1 January, 1899, etc.

These connections coincided with two other events that have brought things full circle – home to our country, and home to my household.

The first was the discovery that a friend of mine, Vietnam veteran and former Jesuit priest Charles Liteky (who I met and photographed in 1986, during his 45-day fast protesting our intervention in Central America) together with his brother Patrick Liteky, and Maryknoll priest and Vietnam veteran Roy Bourgeois, have just been found guilty of civil disobedience. On 16 November, 1990, in commemoration of the first anniversary of the massacre of the six Jesuit priests and two women in El Salvador, these three men poured human blood on the floor and walls of the School of the Americas headquarters, Fort Benning, Georgia. They acted to draw attention to the fact that five of the eight soldiers arrested for the Jesuit massacre were graduates of Fort Benning; indeed, as they point out, thousands of Salvadoran soldiers have been trained at the School of the Americas in recent years.

The second event was the arrival of a glossy brochure from West Point Military Academy at our home a couple of weeks ago, addressed to my son Adam Wilson and soliciting him, because of his 'outstanding performance on college entrance examinations' and 'excellent school achievement', to apply for a 'superior education' on a fully funded scholarship with pay! He thought it sounded great...

I think you can see how I have such a strong sense of history 'coming home to roost', so to speak. Also why I hope to use the computer as a way of interweaving images that fall somewhere between tapestry and bulletin board. that integrate the historical and the immediate...

Hector Méndez Caratini
Xibalba – the underworld

Trisha Ziff Hector Méndez Caratini lives and works in Puerto Rico. I first met him on a visit to the island in January 1990. He works as a photographer and more recently has begun to make videos. During my visit I was fortunate enough to see *Xibalba*,[32] which was on view as part of a group show at the Museo del Arsenal de la Marina in old San Juan.

Hector Méndez Caratini
Xibalba, 1990 (above)

Esther Parada
Define/Defy the Frame, 1990 (overleaf 1)
Untitled, 1991 from the Mexican Uprising Series (overleaf 2)

Taking new ideas back to the old world

Taking new ideas back to the old world

"A US Sergeant in Mexico in Full Field Equipment Consisting of 2 Days' Rations

Description of two stereographs no's 17371 and 17377. From the Keystone View Company

and 220 Rounds of Ammunition."

"Mess Tent. Everyone Has Been Served and All Are Happy."

Pedro Meyer
San Ecologista (above)
Day of the Dead, in Los Angeles (previous)

Pedro Meyer
San Ecologista

'Throughout history, many great civilizations have been buried, none however, by their own trash', so read an interesting advert I saw recently. I guess we are for the most part quite aware of how many ecological disasters threaten our future, and yet we stand there in the midst of all that carnage, with our hands apparently tied, holding our heads like suffering saints who are destined not to do much else but suffer. In the meantime it's business as usual. May this image remind us, if we value ourselves, to engage actively in doing something about the impending ecological menace.

This image was created by 'recycling' parts of images from various sources such as Laser discs, photographic books, and from my own black-and-white pictures, they were all manipulated and put together on the computer, and then printed on an ink jet printer.

I find the notion of *recycling images,* a fascinating one, all of a sudden we find ourselves with the most amazing array of options to choose from, obviously the topic of copyright infringement will become a subject matter for the legal community to ponder on for years to come, in the meantime let's have fun while they still allow us to do so, and we still have a planet to care for.

Day of the Dead, in Los Angeles

This image is a representation of the Mexican tradition celebrating a Day for the Dead. The intense colouration used in this print is derived from the strong chromatic scale so prevalent among the Chicano culture in California (USA). The emphasis on yellow is a deliberate choice, as the warmth and 'hellish' atmosphere is thereby underlined. Two black-and-white photographs taken by me during a celebration of the Day of the Dead in Los Angeles were scanned and then manipulated in the computer. In this image we find pictures of the women depicted both in the 'photograph' itself as well as in the small photographs of themselves, this is a resonance that makes us wonder who they actually represent. Are they alive? Are they ghosts of the women in the small frames coming to share the celebration? Are they both? Is this in the past, or is this in the present? Are we observing a fantasy or are we actually the witness to an extraordinary moment of reality? Who can guide us to what is real?

To produce this image I started out by using my own black-and-white straight photographs, taking them into new directions; first, by introducing colour where there was none before, and then by blending and altering those elements which originally were in the image.

I'm treading on unfamiliar territory, much as with everything else within this reel of experimental work. On the one side is the discovery of what the tools can accomplish, and on the other is the confrontation with how best to use them, something that for practical purposes can only be done through trial and error, and by discovering if they actually go beyond those initial black-and-white images, made through traditional means.

Taking new ideas back to the old world

Working both as an artist and curator, he is constantly involved in a variety of projects. During 1990 he organized a new technology exhibition, '*Arte y Comunicacion*', at the Museo de Arte Contemperaneo in San Juan, both Puerto Rican and Mexican artists contributed to the show. The work was faxed in A4 sheets with layout instructions and then pinned together in a grid format to reconstruct the full image on the gallery wall.

There are many diverse cultural influences present in Puerto Rican society, the most recent and dominant coming from the United States. Méndez Caratini's work reflects these contradictions which co-exist in contemporary Puerto Rico: the pre-Colombian, black and Hispanic cultures, and the modern influence of the United States. With video and digitized images Méndez Caratini's work looks to the past, mixing new technology with ancient myth. In his most recent video, made in the small northern town of Loiza, he explores the island's black African heritage during the festivities of St James the Apostle held every July.

Hector Méndez Caratini talks about the disparity reflected in his work, the forms and technologies he is exploring, and the content of his images, which reflect his own culture and its pre-Hispanic and pre-Colombian roots.

Puerto Rico is at a cross roads. Within the next few years a plebiscite will take place and the people will decide their political future. Whatever the outcome, Hector Méndez Caratini will no doubt remain an artist committed to preserving the cultural integrity of his people.

Hector
Méndez Caratini

To understand present day Puerto Rico, you need to have an understanding of its past history. Puerto Rico is a developing nation with a strong Hispanic (Latin) cultural base. The island has encountered many hardships and dualities due to the post-colonizing effect of the 'American way of life'. A common view held by the population is that this imported culture is superior to our own. Today in Puerto Rico there is a tendency to disregard traditional values and substitute American ones. I would like to illustrate some of these basic points of cultural penetration by using music as my example. Young people from the new-educated generation today like to listen to rock music rather than to Salsa. Salsa is identified as the music of the lower classes; this dilemma creates a gap between the new generation dividing them between *rockeros* (who enjoy listening to American rock music) vs *cocolos* (who listen to traditional Puerto Rican country music). Puerto Rican country music is seldom aired on the radio. This music has been displaced within our culture, and today is aired only at Christmas. The island is fast losing its own identity as it absorbs imported, first-world mass culture from the USA.

Over a decade ago Leticia del Rosario, the then Director of the

Institute of Puerto Rican Culture (a government-funded organiza-
tion), became obsessed with substituting our indigenous culture with
American culture. Reflecting the policy of the Statehood Party, this
institution was active in obliterating and degrading our cultural values.
As a Puerto Rican artist, this became *leña para el fuego* (wood to light my
fire). The current battle being fought in the Puerto Rican Senate is
whether Puerto Rico's official language should be Spanish (which is the
first language of over 99 per cent of the population, and has been so for
the last 500 years) or English, spoken by only 40 per cent of the popula-
tion. The bill regarding the question of language is seen as a battle to
retain our cultural identity. Early in 1991 the United States Congress
failed to pass legislation authorizing Puerto Rico to decide its political
future once and for all.

Another example of cultural penetration in our society was the
changing customs during the festival of St James the Apostle, which is
held annually in Loiza. The inhabitants of this black community were
substituting their traditional costume masks (which were made from
coconuts and symbolized the devils in the war of Paganism against
Christianity), with mass-produced and imported rubber masks of
monster characters from American movies, such as *Star Wars* and *Planet
of the Apes*. These replacement masks are a contemporary example of
the syncretism behind the historical version of the origins of this reli-
gious tradition. During the nineteenth century the black slaves of this
coastal community were worshiping their African deities camouflaged
as Christian saints. Today, a similar schizophrenic equation could be
drawn of these two cultures (the Hispanic and the North American)
coexisting together. Many of these rhetorical arguments can be seen
visually in the video *Loiza*.

In a country where the cultural and political penetration is so visible,
I make a significant effort to show in my photography the importance
of these traditions which make up our culture. I acknowledge that the
society is not static, but is constantly changing. Its cultural ethics are
always being modified, influenced and substituted by new considera-
tions. I am also aware that we are in danger of losing what is our own,
what is specific to Puerto Rico. As a photographer, I see one of my roles
as a documenter of the colonization of our country, as part of the struggle
for our identity.

My photography became a militant vehicle for dialogue in order
that we might acknowledge the importance of our heritage. To the visitor,
our festivities might appear colourful and picturesque; but they have
other implications. Behind all these issues, the basics to which everything
is reduced in Puerto Rico is politics. There are three different political

formulas competing for the future permanent status of the island: these are commonwealth, statehood and independence. Our political future remains an enigma. These are the major issues which influence my work.

Throughout Latin America our art is linked to political liberation, and our reality reflects colonialism. My work is concerned with national identity. I document what remains of our heritage, as well as those aspects which form part of our living culture but are seldom given value within our present reality. The form and the content of my work conflict in a similar way to the reality of daily life within my culture. That is, the content of my work is concerned with third-world Hispanic ideology, while the form is related to the first world. The media and techniques I use range from a traditional photographic format to experimental video and computer imaging. I want to develop new avenues for our forgotten history.

Between 1985 and 1987 I lived in Cambridge, Massachusetts in the USA. I had the opportunity to use facilities at the various colleges to explore this 'new media' which I could not have done at home in Puerto Rico. It was there that I began working on *Xibalba*. I chose to use my time in Cambridge to learn about the available technologies. I was very conscious of my decision. I could have chosen to photograph the Puerto Rican diaspora. I decided not to. At the time, I was reading classical Mayan literature, and became aware of the possibilities of reinterpreting pre-Colombian (pre-Hispanic) myths of creation in contemporary media. I had been reading *Popol Vuh*, which is a sacred book of the Mayan. I had with me my collection of photographs of pre-Colombian petroglyphs (rock engravings), and pictographs in Puerto Rico which I had been working on for fifteen years. I had been documenting the rocks as they were rapidly disappearing (the tropical weather was erasing the fading lines, they had also been vandalized with graffiti, and some had been stolen and removed to private collections outside of the country). I wanted to find a way of preserving them in a way which would interest people today. I studied their symbolism and their relationship to Meso-American mythology.

Since the Indians living in Puerto Rico had been exterminated by the Spaniards when they colonized the island close to five centuries ago, little was known or remained of their belefs and customs. I had read everything that had been written by the chroniclers related to such knowledge, and took the *Popol Vuh* as an inspiration to explore the subject. This video piece explores the epic adventures of the mythical twins Hanahpu and Xbananque in the face of the earth. It tells the story of the creation of the world, the first dawn of mankind, the origins of the human race, the encounters with the lords of *Xibalba* (the underworld), and the

playing of sacred ball games.

In Cambridge I learnt a lot about video, and making programmes for broadcast television. I was excited about the idea of interpreting these ancient rites in new forms; the idea of looking at sacred ball games of the Mayan's on television intrigued me. My colleagues there had computers, laser printers and access to editing suites at the Boston Film and Video Foundation. I had joined this group called Subterranean Video. Back home, there are no organizations like this to support artists. I have to be self sufficient. Whenever I need additional equipment, I have to rent it, or get special access to use a university facility when available. There are few grants available for supporting artists here in Puerto Rico. I approached advertising agencies looking for corporate sponsorship, but they do not support what I am doing. Once I gave a private showing of *Xibalba* to an executive from Sony, hoping that they might lend me a bank of television monitors for an exhibition installation. His response was very negative; he was concerned that the public might think that their monitors were defective!

I was committed to the idea of showing *Xibalba* on a video wall. In the end I rented one for a limited period of time. The wall consisted of sixteen monitors hooked up to a computer to which I programmed sequences of images at random to different monitors, sometimes exhibiting the same image sixteen times; or having one magnificent image across the entire video wall. I was fascinated to observe the moving pixels of colour blown up to such proportions. I enjoyed the sculptural presence of this enormous glass monolith made up of animated coloured light, I was reminded of a scene in the movie *2001*, by Stanley Kubrick, where the apes encounter a mammoth megalith. It is a celebration of the technological advances of mankind on the edge of the twenty-first century. I have seen these huge video walls used in commercials and in shopping malls for selling American automobiles, and as backdrops for pop concerts. However, I hope the video wall gave people the opportunity to stop and think about our history in a way that is pertinent to today.

Xibalba was originally based on black-and-white still images to which I added colour, and manipulated electronically. I enjoy moving from one technique to the other. Today I see myself as both photographer and videographer. The work I did in Loiza was all shot in video, and then I made large colour still images from the video; so I have worked in both media from different directions. Through working in these formats I am beginning to explore new venues for my work. In addition to exhibiting in galleries, I want to show my work on television, where I know my work will be seen by a larger audience.

Pedro Meyer
Post-photographic photography

Trisha Ziff

He describes himself as an 'image maker'. Pedro Meyer is a Mexican photographer who has been working for the last several years, initially under the auspices of a Guggenheim Fellowship, photographing the United States. He works with a variety of technologies and sources to make his images. The technological advances which have brought this intensive art form within the grasp of the individual have made his dreams of exploring these different media a real possibility. Pedro is by nature curious, driven by the desire to find the best forms for communicating his ideas.

While journeying across the US, Pedro Meyer has been working on his personal photographic project. The people and events which he encounters are the subject matter of his photographs and videos. This is the first time a project of this nature has been undertaken by a Latin American.

Having decided to base himself in Los Angeles, Pedro Meyer talks enthusiastically about being in California at this moment in history. 'California today is to new technology what Paris was for painters at the turn of this century'. It is no accident that the developments in electronic media are taking place in California. Video editing facilities, the constant flow of new software, technical innovations in computers used for design are but a few of all the myriad activities which form part of this entertainment capital of the world. Symposiums and conferences are held regularly, where people involved in multi-media have the opportunity to meet and exchange ideas, talk to the authors of discs and the creators of programmes, software and equipment. 'It is the only place in the world where these conditions prevail, where I can be exposed to new developments and have the opportunity to be in contact with other authors, and have the technological infrastructure required', Meyer adds.

During one of his visits to Los Angeles Pedro Meyer met with Bob Stein of the Voyager Company.[33] They began discussing the possibility of Voyager publishing the USA project in electronic media. Bob Stein told me, 'Pedro was interested in going beyond the present limits and borders of how this medium is being used. He wanted to draw together all the elements that have influenced his work, and which he'd experienced, and find a way of conveying all this within a multi-media form.'

Pedro Meyer is pursuing a complicated task. He is involved with the production of his images in both photography and video, and at the same time learning and defining the possible structures which will enable him to deliver his final work (the disc). He states that he cannot go out first and create all the images he might need, because he would run the risk later of discovering he did not take into account different procedures and considerations which might

become significant later on. This has been the case with his video, something that he only entered into his working alternatives recently. The projects described here exist alongside one another. One project is the ongoing photographic essay on the United States, the other is the project with new technologies, which can be described as the delivery system.

For the present, Pedro Meyer and his colleagues are discussing ideas and structures which could make a platform to present his work. They have not as yet defined with which technology they will eventually work. The possibilities include inter-active (or not) video-laser disc, or CD Rom (Compact Disc, Read only memory). However, by the time the photographic and video images for the project have been completed, there will most probably be new factors to take into account, such as advancements in compression technologies or new, less-expensive hardware on the market, something with which to play back the discs.

The following texts are extracts from three different discussions concerning the development of the inter-active disc of Pedro Meyer's project on the US.

The first section is a personal interview between Pedro Meyer and myself, which took place in April 1991, where he describes some of the ideas he has been developing and discusses his latest involvement using the Iris 3024 digital ink jet printer,[34] a state-of-the-art process which he is experimenting and above all, as he says, having fun with.

The second section is taken from an address by Pedro Meyer and his disc editor Fred Ritchin to a group of developers of similar projects at the Multi-Media Designers' Conference,[35] held in February 1991 at Laguna Beach California.

The third section is an extract from a more informal discussion which took place at the Voyager Company two weeks before the conference.

You have been working on ideas for the disc on the United States for some time now. How much closer are you to finalizing the form the disc will take?

All the discussions about the disc have helped us to gain clarity. I think that the form of the disc remains our main concern, not the content. I will continue to photograph and video my observations of life which I encounter as I travel throughout United States. At the same time, I am discovering that all these new technologies and tools have opened up new opportunities for me to express myself. I have always found photography magical. The magic of the image emerging through the chemicals in the darkroom remains with me to this day. As I work with the computer and the image comes through on the screen, I find myself back in the darkroom. I am exhilarated by the process. The new-found Pedro Meyer

speed enables me to explore, whereas in a similar situation in the dark-room the process would be too cumbersome and slow.

Working in multi-media is very compatible with the way I think. One of the things which I love do to most is to bring different elements together and create new meanings. Using video and photography together offers me great opportunities to do this. Today I am freeze-framing from broadcast television, and using my own video. I think television is America's most significant cultural export. Look at Mexican television: the majority of programmes are imported from the US. The influence of cultural values from the United States is widespread. One idea which I have wanted to work on now for a long time is to edit together fragments from all these American television talk shows, of politicians and experts talking about what the US should do with the rest of the world. It is as if they own the world. Constantly statements are being made that 'we (the USA) should do this, or should do that'. I would like to take these fragments and put them together with my images and create new meanings.

Trisha Ziff How do all these different aspects of your work relate to one another? Your photographs, videos and most recently the Iris prints?

Pedro Meyer Think of my work as a wheel that has many spokes. Each one of these spokes for me is a new way of creating images. In the past I have said that the chemical image has lost its monopoly. As a consequence of this, the entire concept of photography has had to change. Now we are talking about the electronic image as well as the chemical image. What I find so challenging is to satisfy my curiosity, to find out what is around the corner. How can an idea become a reality? How does one achieve the ability to communicate one's thoughts better?

I am beginning to use colour in my personal work, which is something I have not done for many years. I have created these colour images using the computer and the Iris printer. Before I could not control the colours I worked with, whereas today I am choosing the colours. This is a big difference. We could call it 'digital hand tinting' or perhaps 'electronic painting'. The images that I have made so far with the Iris printer are about having fun, they are explorations. Two years ago when I was beginning to print in colour with the Apple Image Writer, the work I made was very crude. When I was looking at those early images I could see the potential somewhere down the road for what I was doing, I was imagining an Iris printer. I knew the technology would be developed. I can compare the Iris prints with this early work. It is the same with the disc: today we are experimenting, but at some point in the future all this work will come together.

By choosing to work with new technology aren't you limiting yourself to a very narrow audience for the foreseeable future?

Right now, in relation to the disc, that is true. However, I am also working towards an exhibition of my photographs on the United States, and a book. So there is a gradual escalation, and there are also offshoots from my main body of work. That is why these technologies are so exciting to look at, they bring into the medium an array of new opportunities and possibilities. The downside is that it's possible to become so caught up in endlessly exploring, with little to show for it; that's a problem. There is a risk of wasting a lot of time. As it is, I would say 50 per cent of my day is spent fixing what went wrong, 25 per cent learning, and 25 per cent creating.

My motivation has to be very clear. For example, editing video is something I have never done before; I feel like I am going to school, I am constantly learning. I find everyone else working in this area is in the same situation. It is almost impossible to keep up with the enormous breakthrough in technology.

When I was kid, I would stand against the wall and someone would draw a line to measure how tall I was then. Six months later I would be two inches taller. I couldn't believe that I had grown that much. I never sensed that growing process, the only reference I had was that line. The same is true for me today. I am not clear as to what I have learnt, the changes are gradual.

In the past, I didn't have the options of using video (with sound) or a still image. The alternative of video represented something totally outside my reality, it required a whole crew and expensive equipment to do that. One can say the same held true for computers until five years ago; only large corporations, governments or major institutions and universities had such equipment available for the purpose of image manipulation or design. It was out of the realm of the individual artist working on his own. But in the end all of this is only important insofar as it enables the delivery of ideas in ways that might expand the horizons of knowledge and experience.

This second extract is taken from an evening event held during the Multi-Media Designers' Conference – Pedro Meyer, author of a future disc on the United States and Fred Ritchin, his editor, were invited by Bob Stein of the Voyager Company to present their project. Here Pedro and Fred are discussing some ideas relating to the disc.

Pedro Meyer The opportunity of working with multi-media makes me think that here is a challenge to share with the viewer those diverse aspects which were part of my original experience while taking the photographs. By presenting my work in the form of a disc, it would also give the viewer the option to select which images to linger over, or the opportunity to go through my images without adhering to my version or viewing order.

My project on the United States is still in progress. I still need to photograph at least 45 per cent more of the images towards my final edit. Anything that I come across while on my travels I consider as an opportunity to express my opinions on the United States. Why the USA? The entire world is effected by the United States. The fact that most cultures in the world are so influenced by what goes on here needs to be inspected closely and commented upon. This is what motivates my work. It is precisely because of this US global influence, as well as the interaction between the United States and my country, that I undertook this journey.

Fred Ritchin One of the ideas expressed by Pedro which attracted me to this project is a statement he made: that the United States can be seen as an exporter of material values, but may soon find itself as having to be an importer of spiritual values. I think his project is concerned with the visible, yet expresses the invisible. Often we don't even see what surrounds us, because we are so immersed in it. It's like the fish is the last to see the water. Pedro with his 'outside eye' sees things we don't see. His images are ambiguous, they are metaphoric, they have many different meanings. His photographs are spontaneous, open and complex, they invite you to react, to interact.

One problem with a linear book format is that the photograph cannot have many allusions; whereas with a disc it is possible to leap from image to image, return easily to the previous one, discover more information beyond the photograph which the author has chosen to extend to the audience. The user will have the choice as to how much information he or she wishes to discover, as well as having the freedom to simply look at the photographs. There is a lot more work to be done. This is just the beginning of our investigation.

One idea we have discussed for the disc has been to record a wide range of people whom we have shown some of the photographs to, talking about what they have seen in the images. These recordings are something we might choose to put on the disc, that the user would then have the option of accessing. For example on one channel Pedro could speak about an image, on another channel someone else would give their interpretation. The user might have the possibility of adding their own comments too. We have also talked about how we are going to

sequence the photographs. Can the same images reappear? How might different sequences change the reading of certain images? How can we construct a disc that goes beyond presenting a linear format? The disc has so many possibilities to offer, we don't want to reproduce a digitized exhibition or book.

Pedro has talked about the 'borders' in this project – between Mexico and the United States, between old and new technologies, between new and traditional ways of thinking. At present, we are in the process of pulling together different elements, looking at their relationship to the photographs, finding ways to bring all this material together – the photographs, the video, Pedro's diaries, the work of other photographers and writers on the United States. The photographs would form the primary journey; then the user would be able to make all sorts of side trips, creating the possibility to look at Pedro's interpretation of the US from different vantage points.

During the evening Pedro Meyer showed a selection of one-hundred black-and-white slides made from prints of his work on the United States.

Trisha Ziff

I find it interesting that we would present to you this work in the simple form of a slide show in black and white, and without a soundtrack, to illustrate this ongoing project to make a disc, a complex technology. The slide show would be presented as the top layer, the first thing that the viewer comes into contact with on opening the disc – an exhibition for the audience to browse through. In adding subsequent layers to the disc, I would be able to enhance the information available. These layers could be accessed according to the user's discretion.

Pedro Meyer

I think that every medium has its limitations. I have been involved in the creation of many photographic books. In the layout, I have always taken into consideration the design and sequencing of the book from beginning to end, all designed to be read from front to back; yet most people look at photography books from the back, or in a chaotic manner, and they still manage to make sense of it. This has led me to think that randomness really works.

The following extract is from an informal meeting which took place at the Voyager Company with the following people:

Pedro Meyer, author of the future disc on his personal work on the United States; Jonathan Green, Director of the California Museum of Photography at Riverside Museum, who will be hosting a major exhibition of Pedro's work in

November, 1992; Bob Stein, a director of the Voyager Company, who is working closely with Pedro Meyer on the development of the disc. Aleen Stein, a director of the Voyager Company; Fred Ritchin, curator and writer on photography and computer imaging who is working with Pedro as his disc editor.

Jonathan Green **While I understand the need for structuring the disc, I would like it to retain a chaotic quality, to force the user to move away from a sequence of photographs. The pacing could become the user's own rhythm – its intention, to pull you in. The users will have to draw their own conclusions. It should not be possible just to watch the screen. I want it to be a little bit more cacophonous than a series of images, something more than a polite sequence. I would move from image to diary, to video, to digital, with the possibility of recreating a quality of your working process which is not that polite, which is more aggressive, more questioning as you move from media to media. I hope that we can reproduce this quality and build it into the score, into the flow. I think that if we set up a hierarchy of layers where the photograph is always on top, it will be antithetical to the way that you really think and feel. The photograph is not always on top. Sometimes it's irrelevant. At times you're working backward towards a photographic image, and at other times you see it immediately as a digitized image at the point you're taking the photograph, or at the point you are making the video. At different moments, these different media are primary for you. Their relationship to each other and to what you are saying is what I feel is important.**

Bob Stein **Some time ago we created a game – 'Play the Encyclopedia Britannica' – where the user would take two words at random, and would then try to find the most interesting relationship between the two words. We posited it as an arcade game, where you would put in a quarter and get elegance points for the connections you made. Earlier, when we were talking about a game the energy level increased. It is like a child playing in a sand box with different elements, exploring and experimenting and discovering; I feel that we should try and create these qualities.**

Jonathan Green **In a way what you are doing, Pedro, is a kind of game. You are playing with a range of materials and media which then focus around certain major issues of contention, the way in which you see the world. I am not opposed to the game notion at all, as long as it does not trivialize.**

Fred Ritchin **Perhaps the museum version of the disc might have to be different to the home version. The home version could have the possibility to be studied more deeply; you would want to keep returning to it. It would**

have many more levels. Perhaps the use of the word 'game' or 'play' might be more appropriate for a museum environment and less appropriate for a home environment.

I don't think that the museum disc has to be so much simpler; I think it can be incredibly intricate. The question is: can we make it so it will suck people into it? We want to be able to draw people in, engage people in the images and the ideas that they generate. I think it's possible. I know it's possible.

<div align="right">Jonathan Green</div>

I think that the museum disc has to be complex and have many different levels to explore, because people do things at different speeds and with different interests and concentration levels. When I watch people going around exhibitions I am aware that some people spend half an hour browsing, and other people take hours and read every caption and take in every detail. The disc has to have the flexibility of supporting these diverse needs.

<div align="right">Aleen Stein</div>

I envisage that the gallery might have about twenty to thirty monitors interspersed between the photographs hanging on the wall. Many people would then have the opportunity to sit down at the same time...like twenty telephone lines. Ideally there would be a monitor for every print hanging on the wall.

<div align="right">Pedro Meyer</div>

Another possibility might be if we were to disperse these monitors and segregate the media, so that one monitor works as a photographic work-station, another a digital work-station, a third would be a video work-station. Then we could create a dialogue between multiple monitors. If we eventually make a home disc, then we could pull all these media together on one monitor; but why limit the potential that the gallery has to offer in our thinking?

<div align="right">Jonathan Green</div>

I think creating the same disc for the home user and the museum makes sense. The fact is that technology today is not that readily available to most people. By having several monitors in the context of the gallery, many more people will have the opportunity of experiencing the disc. It not like a video, which can easily be rented and played at home on a VHS recorder.

<div align="right">Pedro Meyer</div>

So here we have all these monitors set up next to each other, and we are negating so many of the applications these machines can do. Wouldn't it be more interesting to have some communication back and forth

<div align="right">Jonathan Green</div>

between the monitors...between the audience?

Aleen Stein I think there are certain kinds of programmes or discs which are much more interesting, because they are designed to be co-operative. If a group of people are gathered together around a monitor and are encouraged to participate, they not only have a good time, but they learn from each other too. There is a game that is played called *Networking*, where people sit at their own computers and play against each other, instead of against the computer. Here, the users could interact with each other. They could pull up photographs on to the screen, discuss them, compare them with other images, develop new sequences, even talk to each other – which is something people rarely do when they go to an exhibition!

Fred Ritchin Perhaps we could create a different slide-show as another layer, with a selection of Pedro's photographs from both United States and from Mexico. If we devised a tool which operated as a lever, like the arm of a Las Vegas slot-machine, we would establish a situation where the user would see arbitrary juxtapositions of images instead of a highly-structured sequence. This way we would be unable to preplan the juxtapositions; the images would appear on the screen in random configurations.

Jonathan Green I have experienced a similar technique used in new music. Two different pieces of music start together at different tempi, and after about five-hundred repetitions the music returns to the same point where it began. During that cycle you cannot anticipate what you are going to hear until the music has gone full circle.

Pedro Meyer What you are saying reminds me of children. They always like to hear the same story repeated again and again. I think adults are not so different. Many people are scared of new technology. They are afraid of change. I am amazed at how defensive people become when they are confronted with taking on new ideas and processes. I feel that the topics that I photograph are already intense, and provoke a certain defensiveness. If we put it in a context where the form in which they are experiencing the photographs is also new, I think the audience might be turned off completely. If that is the case, then there is little possibility of getting across any ideas. So I am less inclined to have everything 'out on a limb', because if I alienate the audience I might as well be talking to myself.

Jonathan Green I don't want people to be overwhelmed with the pyrotechnics of how the disc works. I think the movies are a good example of incredible

technology: when it works it is totally absorbing; you live it while it is on the screen, you don't think about how it was made. My hope is that when the disc is finally completed, the computer screen will be so compelling and inter-active at the same time that the audience won't sit passively. It will want to engage.

To make it compelling and inter-active, we have to make it entertaining. Pedro Meyer
For me that is a key ingredient. There has to be something going on that gives the user feedback and keeps the audience motivated and interested in participating. Just intellectual speculation – this image goes with this, and this image goes with that – is not enough.

Inherent in your photographs on the United States is a sense of humour Jonathan Green
as well as narrative and irony – an interesting combination. These elements are entertaining. I think we need to emphasize what the work is about and not configure it in some wild new way.

For me, one of the limitations I find with inter-active discs is that once Pedro Meyer
you have explored the whole disc, you're then finished with it. You rarely return for a second time, much as with a novel. This is not the case with a book of photographs where people certainly return and look at the images over again. I don't have a problem keeping a book that I have read, but I don't feel the same about a disc. It's a bit like renting a video: I rarely rent the same video twice. We have to make something that transcends this.

When a book sits on the shelf, it's always there. I think a disc is more Bob Stein
ephemeral – perhaps I don't quite know how to put a disc on the shelf. Records and books are the same in that sense, you put them on the shelf and they become part of your life. They don't disappear. Where as when you stop using a disc where is it ? This is a problem...

It's a metaphysical problem... Jonathan Green

During the process of writing this article and the discussions I had with Pedro Trisha Ziff
Meyer, he has now completed a new piece of work, *I Photograph to Remember*, a CD Rom published by the Voyager Company. The work is a personal account of images made during the last three years of his parents' lives. A collection of black-and-white images with a text narrated by the photographer with music composed specifically to accompany the photographs.

The CD Rom was seen for the first time in Los Angeles on 6 June 1991 by an audience at Digital World.[36] This technology creates the possibility to publish a slide show in a form which can be shared by a wide audience with high quality resolution, something a VHS video cannot deliver. The work is the first of its kind and has the potential for changing the face of photographic publishing.

1. Marshall McLuhan, *Understanding Media, The extensions of man*, Mentor Book, Penguin USA 1964

2. Adrienne Rich, 'Notes toward a politics of location', in *Blood Bread and Poetry: Selected Prose 1979-1985*, p212

3. See Pedro Meyer, *Post Photographic Photography*, third section of this article

4. James Clifford, 'On Ethnographic Authority' from *The Predicament of Culture*, Cambridge, Harvard University Press, 1988 p51

5. Extract of letter written from Esther Parada to John Frohnmayer, Chairman, National Endowments for the Arts, August 1990

6. Largest annual exhibition of Macintosh computers and software held in the US

7. Chairman of Apple Computers

8. David Weir and Mark Schapiro, *Circle of Poison: Pesticides and People in a Hungry World*, San Francisco, Institute for Food and Development Policy, 1981. The papiermaché masks integrating texts from this book were made by Parada for an installation in 1986

9. Text woven into the papiermaché mask in *Circle of Poison*

10. Electronic publishing house in Santa Monica California

11. Extract adapted from a letter to Esther Parada from Trisha Ziff, 16 January 1991

12. An American TV game show

13. Extract of letter from Esther Parada to Trisha Ziff, 21 January 1991

14. *Memory Warp I, II, III* were made in 1980. The three composites form a portrait series of Parada's father, and include images from his family history, as well as elements from his life as an insurance salesman and cantor. The title *Memory Warp* has a double reference: to the 'warp and woof' of weaving threads and to the 'warp' of distortion. The works are in the permanent collection, Art Institute of Chicago

15. *Past Recovery*, a 1979 photographic wall piece, based on a 1920 group portrait from her mother's family. It is in the permanent collection, Museum of Fine Arts, Houston, Texas

16. Lucy Lippard, in *Voices of Women: Three Critics on Three Poets on Three Heroines*, New York, Midmarch Associates, 1980, cited in 'Women's Vision Extends The Map of Memory' by Esther Parada, *Michigan Quarterly Review*, Winter 1987 p217

17. Extract of letter from Esther Parada to Trisha Ziff, 21 January 1991

18. Adapted from Option/Shift (an annotated interview with Esther Parada by Deborah Bright) published by Platen Press, Dept of Fine Arts, University of Colorado at Boulder, 1989

19. Extract from Esther, telephone conversation, March 1991

20. *The Monroe Doctrine: Theme and Variations*, 1987. 168 laser prints, 12 x 8 ft, see *Digital Photography* catalogue, SF Camerawork, 1988, and *Option/Shift* for more information

21. Interview with David Hockney by William Leith, *Independent on Sunday*, 21 October 1990. Quotation chosen by Trisha Ziff

22. Cover article 'Furor in the Gulf', *New Republic*, 11 September 1990

23. Adapted from *Option/Shift*

24. Adapted from *Define/Defy the Frame*, published by the University Art Museum, SUNY, Binghamton, New York, 1990

25. ibid. p16

26. Chuck Kleinhans, Chicago-based film and video-maker, co-editor of *Jumpcut*

27. Adapted from *Option/Shift*

28. Photo-text work published in 'Women's Vision Extends The Map of Memory', *Michigan Quarterly Review*, Winter 1987 pp198-203

29. Margaret Randall, *Sandino's Daughters: Testimonies of Nicaraguan Women in Struggle*, Vancouver, New Star Books Ltd, 1981

30. Adapted from 'Multiple Resolutions': talk given by Esther Parada at the Philadelphia Sesquicentennial Symposium, June 1990

31. This interactive installation, *2-3-4-D: Digital Revisions in Time and Space*, will include a one-week residency by Parada at the CMP, when she will digitally incorporate responses to selected stereographs from interested viewers, as well as students and scholars she has contacted

32. *Xibalba* translates as underworld, interpretation of the sacred Mayan book of Dawn, *Popol Vuh*. The work is shown on a 16-colour monitor video wall driven by a computer, the work consists of manipulated digital images and electronic sound, accompanied by 35 colour photographs. First shown at 'Foto 90' in Puerto Rico

33. Established in 1986, Voyager is a publishing company exploring the uses of new electronic media. Perhaps unique, Voyager is committed to producing content-driven projects while grappling with the daily problems of working at the cutting edge of new technology

34. The IRIS 3024 ink-jet printer was introduced onto the market in 1987, however until recently it was used only for applied design work, primarily in advertising and cartoon production. In the last year a few artists have began to work with the technology. It is a chemical-free process using water-based vegetable dyes. The IRIS is driven by a computer which contains the digitized information of the image. The printer can print onto any paper providing it is flexible enough to wrap around the drum. This printer uses paper sizes up to 24 in x 24 in

35. The Multi-Media Design Conference was organized by the Aspen Institute Programme on Communication and Society with the Voyager Company. The conference was a closed event for designers in the field of CD Rom inter-active discs

36. Digital World – a Seybold Seminars Event – held at the Beverley Hills Hilton, Los Angeles, 4-7 June 1991